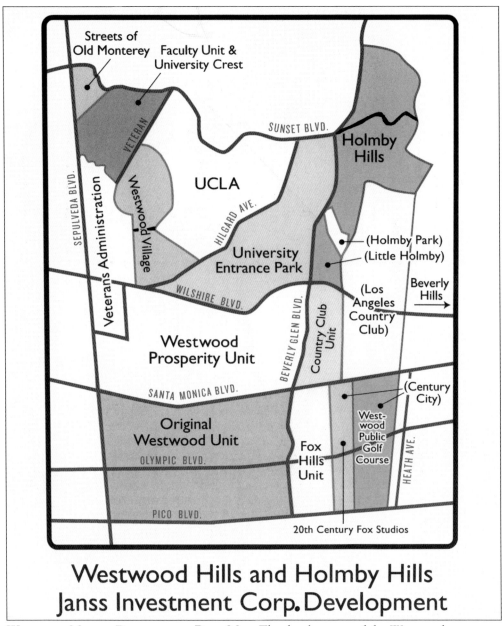

WESTWOOD MASTER DEVELOPMENT PLAN MAP. The development of the Westwood area was a complicated project encompassing thousands of acres. Eleven development units were planned and realized from the 1920s through the 1950s. The Janss Investment Corporation created one of the greatest developments the Los Angeles area has ever seen.

ON THE COVER. Facing north on Westwood Boulevard across Wilshire Boulevard in 1948, the Westwood Village business towers can be seen from miles around. The Union 76 Gas station and three others along Lindbrook Drive have since been demolished. Since Westwood Village's initial development in 1929, many businesses have come and gone, while some have endured as mainstays for more than 80 years. (Courtesy of Bison Archives.)

IMAGES
of America
WESTWOOD

Marc Wanamaker

Copyright © 2010 by Marc Wanamaker
ISBN 978-0-7385-6910-9

Published by Arcadia Publishing
Charleston SC, Chicago IL, Portsmouth NH, San Francisco CA

Printed in the United States of America

Library of Congress Control Number: 2008942871

For all general information contact Arcadia Publishing at:
Telephone 843-853-2070
Fax 843-853-0044
E-mail sales@arcadiapublishing.com
For customer service and orders:
Toll-Free 1-888-313-2665

Visit us on the Internet at www.arcadiapublishing.com

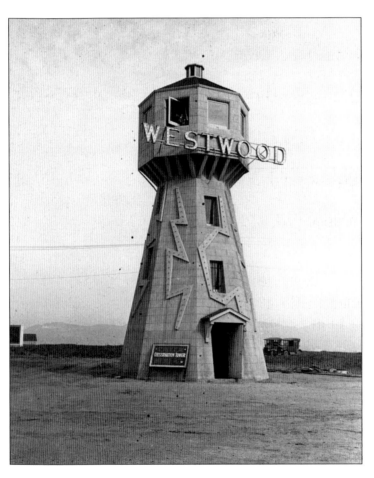

WESTWOOD OBSERVATION TOWER, 1928. This unusual edifice, a four-story wooden tower erected by the Janss Investment Corporation in the 1920s, was once located on the northeast corner of Wilshire and Beverly Glen Boulevards. At 420 feet above sea level, the highest point on Wilshire Boulevard in the Westwood development, it served as an advertisement and gimmick, allowing potential property owners to climb the tower to peruse their lot and get the big picture of the new community. The name "WESTWOOD" and the lightning bolts were illuminated and could be seen for miles.

Contents

Acknowledgments		6
Introduction		7
1.	Early Subdivision of the Ranchos	9
2.	The Letts and Janss Families	17
3.	Original Westwood Tract and Fox Hills Units	23
4.	Westwood Prosperity and Country Club Units	35
5.	University Entrance Park and Holmby Hills	55
6.	UCLA	69
7.	Westwood Village: 1925–1939 North Village, University Crest, Streets of Old Monterey	81
8.	Westwood Village: 1940–1959	101
9.	Westwood Village: 1960–2009	109
10.	Motion Pictures and Television	115

Acknowledgments

The Westwood-Holmby Historical Society was founded in 1989 as part of the 60th anniversary celebration of Westwood Village. Established as a California nonprofit public benefit corporation, its purpose is to foster awareness and appreciation of the rich history that the Westwood Village and Holmby Hills communities and UCLA have contributed to Los Angeles. Kirsten Combs, a founding director, provided space for the group in her historic Contempo Westwood Center building (originally constructed in the 1920s as the Masonic Affiliate Clubhouse for UCLA students). She and her husband, Donald, had collected historical photographs and information on Westwood since 1975 and created an 80-foot-long panorama exhibit on the second floor of that building. The exhibit became a landmark in Westwood Village for many years.

Early founders and board members of the society included Sandy Brown, Rubi Chatalian, Greg Fischer, Tom Franklin, Carolyn Mannon Haber, Jeff Hyland, Wendy Kaplan, Gina Lain, Katy Lain, Elliot Lewis, Carole Magnuson, Dona Van Orden, and Marc Wanamaker. The society's mission statement read, "Our purpose is to protect, preserve, and promote the architectural integrity and cultural heritage of Westwood-Holmby, originally part of Rancho San Jose de Buenos Ayres."

The society's inauguration party on October 24, 1989, hosted by George Rosenthal, owner of the Westwood Marquis Hotel and Gardens, celebrated the 60th anniversary of the opening of Westwood Village in September 1929. At the party, this author reprised a slideshow, "History of Westwood," which had previously been presented at the Westwood Playhouse. "Westwood Week," from October 20–27, included lectures and tours at UCLA, "Nostalgia Day" showings of classic films at the Mann Westwood Theatre, and walking tours of Westwood Village.

The year 2009 marked the 20th anniversary of the Westwood-Holmby Historical Society and the 80th anniversary of Westwood Village. This first book on Westwood history is dedicated to the society. Over the last 20 years, the society has made contact with several longtime former residents, including Barbara Lain, Lett Mullen, and other descendants of Westwood's founders. In 1993, film director Andrew Stone and supervisor Ed Edelman, Howard Henkes, Bill Bullis (Letts family member), and Ann Garfield expressed interest in bringing back some of the "old Westwood," including the original wrought-iron tiled lampposts. Over the next few years, one of the last remaining original Janss-era lampposts was reinstalled on Westwood Boulevard next to the historical Janss Dome building. In 1998, the society, in cooperation with the many residents and community groups, initiated the designation of Glendon Manor to the California Register of Historical Resources along with many other designations that the society helped identify and support.

Input and proofing were supplied by Greg Fischer, Tom Franklin, Carolyn Mannon Haber, Jeff Hyland, Katy Lain, and Tommy Ryan. The author expresses special thanks to Steven Sann for invaluable editorial contributions to this book. The photographs in this book appear courtesy of Bison Archives and the Westwood-Holmby Historical Society.

—Marc Wanamaker
2010

INTRODUCTION

The areas known today as Westwood, Holmby Hills, and UCLA were once largely a parcel of 4,438 acres granted to a retiring Spanish soldier, Don Maximo Alanis. He named this hilly place speckled by sycamore groves and fanned by ocean breezes "Rancho San Jose de Buenos Ayres." The rancho extended from what are today the foothills of the Santa Monica Mountains to the north, south to Pico Boulevard, east to the city of Beverly Hills, and west to Sepulveda Boulevard. Alanis ranched the land from the 1820s to the 1840s, although he was not granted formal title to the land until 1843. He died shortly thereafter, and in 1851, the heirs of Alanis were forced to sell the rancho.

The land changed hands several times over the next few decades, remaining a working ranch and farm. In 1884, John Wolfskill, a former state senator and rancher who came to California during the Gold Rush, purchased the property for $10 an acre, or roughly $40,000. In 1887, in cooperation with the developers of the city of Santa Monica, Wolfskill deeded 300 acres to the federal government to create what is known today as the Veterans' Administration and the Los Angeles National Cemetery. That same year, he sold the remainder of his ranch to the Los Angeles and Santa Monica Land and Water Company for $100 an acre.

The "Town of Sunset" was plotted, some lots were sold, a railroad was built through the property, and a Grand Hotel was constructed near the intersection of Wilshire and Beverly Glen Boulevards. The venture failed, however, and in 1891, the land was quitclaimed back to Wolfskill, who resumed farming it until his death in 1913. The Sunset Cemetery (now Westwood Village Memorial Park) is all that remains from that development. Acreage also was sold to the Los Angeles Country Club in 1904 and later to the Danziger family, who subsequently sold it to Alphonso Bell, the developer of Bel-Air.

In 1919, the remaining 3,300 acres were sold by Wolfskill's heirs to wealthy retailer Arthur Letts, founder of the Broadway department store and financier of the Bullock's department store, for the unheard of sum of $2 million (about $600 an acre). Letts was primarily interested in developing estate parcels in the northeastern hills of the ranch, which he named "Holmby Hills." Arthur's son-in-law, Harold Janss, was vice president of the highly successful Janss Investment Corporation. He and his brother, Dr. Edwin Janss, viewed the southern end of the property as an ideal location for a middle-class Westside subdivision, and Letts gave them an option to develop the land. By 1922, they actively promoted "Westwood Hills" homesites between Santa Monica and Pico Boulevards. The Janss brothers oversaw all aspects of the development and employed their own architects, public works engineers, and builders.

In the 1920s, the Fox Film Corporation purchased a large parcel on the southeastern border of the property. Film star Harold Lloyd located part of his studio at the site of the old Wolfskill Ranch house north of Santa Monica Boulevard, near Overland Avenue. On the northern property, the area was considered too hilly for large residential subdivisions. Letts, formerly a trustee of the Los Angeles State Normal School on Vermont Avenue (eventually the Southern Branch of the University of California), became interested in expanding and relocating to his land. His death in 1923, however, left this dream unrealized. The Janss brothers, executors of the Letts Estate, persevered. In March 1925, after considering 17 sites, the University of California Board of Regents decided on the "Westwood-Beverly Hills" site. The Janss brothers offered the regents 300 acres at $2,000 an acre and 75 acres at $7,500 an acre. Bond issues were passed by the cities of Los Angeles, Beverly Hills, Santa Monica, and Venice to raise the $1.3 million necessary to acquire the land and deed it to the regents. Additionally, Alphonso Bell donated 8 acres of his Bel-Air property to complete the parcel. Development of the Holmby Hills estate district began in April 1925 by the Janss Corporation on 400 acres of the most picturesque portion of the former rancho.

Westwood Hills was annexed in 1926 by the City of Los Angeles, and the Janss Corporation planned a business and residential community to support the new university. By September 1929, when the University of California at Los Angeles opened the doors for classes on its new Westwood campus, the charming Mediterranean-style Westwood Village was designed, and a few buildings were open for business. Despite the onset of the Great Depression just one month later, the area became an acclaimed model community with a premiere shopping, business, and entertainment district serving UCLA, the studios, and adjacent residential and estate neighborhoods.

A dozen or more soaring towers located throughout Westwood Village served to attract and orient motorists, while pedestrians were drawn by deep sidewalks, beautifully landscaped avenues, inviting courtyards, and open-air patios with decorative tile fountains and stairways. The Janss Company's planning for its Mediterranean-themed village and demand for strict adherence to building quality and design, including an architectural jury, paid off. Westwood Village became one of Southern California and the nation's most successful shopping districts.

In 1955, the Janss brothers retired from developing Westwood and sold their remaining interests in the Village. Over the years the surrounding residential communities have grown into a gracious maturity. Changes in city building and zoning laws and height and setback restrictions, once integral to the aesthetics of this unique community, have altered the scale and density of Westwood. The quiet little rancho of 160 years ago is now a thriving complex of homes, apartments, condominiums, businesses, and educational facilities.

In 1999, the Westwood-Holmby Historical Society celebrated the 70th anniversary of the opening of Westwood Village with the following statement: "How many of us recall the Westwood of Yesteryear . . . our gracious Mediterranean-style Village with its towers, arches, tiles and ironwork and wide tree-lined sidewalks with courtyard dining and quality shopping. Although change is inevitable, we believe that sound community planning should include reinvesting in our historic resources. The Westwood-Holmby Historical Society continues to research and document our history so that we may provide local residents, business owners, property owners, developers, schools, and homeowner associations with historical information and photographs. Our hope is that educating the community about our architectural heritage is the first step toward encouraging preservation."

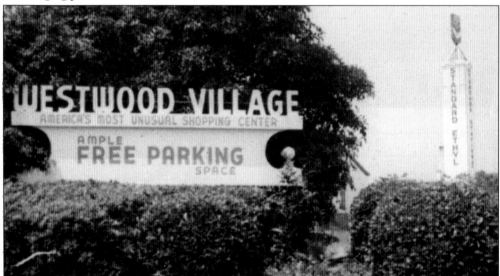

Westwood Village Entrance Sign, 1938. Here is one of the two Westwood Village entrance signs, located prominently on the northwest and northeast corners of Wilshire and Westwood Boulevards, advertising the "Ample Free Parking Space" that was available. The signs touted Westwood Village as "America's Most Unusual Shopping Center."

One

Early Subdivision of the Ranchos

Native Americans had been crossing the Santa Monica Mountains on the trail through the Sepulveda Pass for years when, in August 1769, Spanish explorer Gaspar de Portola and his soldier-explorers passed through the area en route from Baja, California, to the settlement of Los Angeles.

Although title to the Rancho San Jose de Buenos Ayres was not granted until 1843, the land was occupied by Don Maximo Alanis in the early 1820s. The grant included 4,438 acres east of the Sepulveda Trail. Alanis and his wife had journeyed from Sinaloa, Mexico, to reside at the Pueblo de Los Angeles. After his retirement, he was awarded the land grant and built a new adobe in a grove of sycamores near a spring near what became the northern boundary of UCLA. Alanis maintained his pueblo home and spent the summers at the rancho. Don Maximo Alanis died soon after Gov. Manuel Micheltorena granted him clear title to the rancho on February 24, 1843. His heirs sold the rancho to Dr. Wilson W. Jones and William T. B Sanford.

In 1848, the treaty of Guadalupe Hidalgo brought California under U.S. sovereignty. In 1852, Don Benito (Benjamin Davis) Wilson purchased Dr. Jones's interest in the rancho for about 35¢ an acre. Wilson and Sanford raised cattle. In 1858, Wilson acquired the remaining interest in the rancho from Sanford. In 1884, John W. Wolfskill bought Rancho San Jose de Buenos Ayres for about $10 an acre, and in cooperation with developers of the city of Santa Monica, a total of 640 acres were deeded for a National Soldiers' Home (today's Veteran's Administration and Los Angeles National Cemetery).

In 1887, the Los Angeles and Santa Monica Land and Water Company, anticipating a continuing subdivision boom, purchased the rancho for more than $100 per acre, intending to establish one of the many boomtown sites of the 1880s. A townsite was laid out and named "Sunset"—the first use of that name. Lots were surveyed and staked, and a railroad was built. A Grand Hotel was constructed near the corner of Wilshire and Beverly Glen Boulevards. The Sunset Cemetery was established near present-day Wilshire Boulevard and Glendon Avenue. But the boom turned to bust, and in 1891, the land reverted back to Wolfskill, who resumed ranching.

About 1,000 acres of the original rancho had been sold by 1919. Matt Wolfskill, son of John Wolfskill, then owned the remaining property and refused to go to escrow or be bothered with a title. He said, "I own the land, and everybody knows that I own it. You give me the cash and I'll give you a deed."

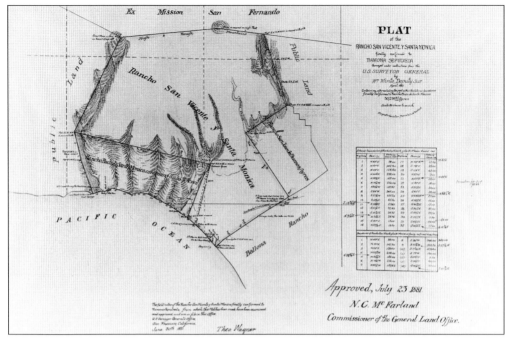

SURVEY PLAN, RANCHO SAN VICENTE Y SANTA MONICA, 1881. This plot plan map was officially conveyed to Ramona Sepulveda in April 1881, containing the 30,259-acre rancho. Adjacent to this great rancho was the Rancho San Jose De Buenos Ayres, future site of the Westwood Hills, Holmby Hills, and UCLA developments, which is the same section at right on the plan.

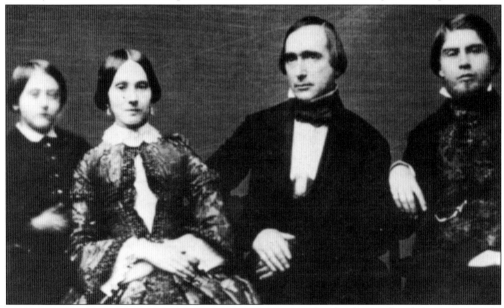

BENJAMIN DAVIS WILSON AND FAMILY, 1878. Don Benito Wilson is depicted with his second wife, Margaret, and his son and daughter. In 1852, Wilson purchased a large interest in the Rancho San Jose de Buenos Ayres. By 1858, he acquired the entire rancho for 35¢ an acre and grazed cattle there until 1884, when it was sold to the Wolfskill family. Wilson was the second mayor of Los Angeles and grandfather of Gen. George S. Patton Jr.

JOHN W. WOLFSKILL, 1884. The nephew of the famous California pioneer William Wolfskill, who died in 1866, John Wolfskill purchased the Rancho San Jose de Buenos Ayres in 1884 for $40,000 ($10 an acre). John Wolfskill lived on the rancho until his ranch house was destroyed by fire in 1910.

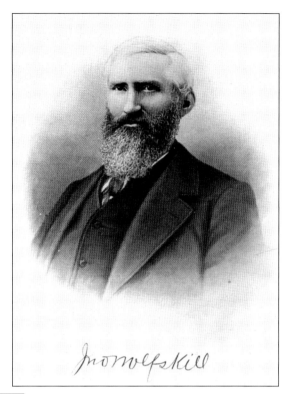

DEED TO THE RANCHO SAN JOSE DE BUENOS AYRES, 1884. John W. Wolfskill, the son of Mathus Wolfskill, came to Los Angeles to live with his uncle William—until his uncle's death in 1866. John had sold parcels of other California rancho properties and introduced the large-scale lima bean culture into Los Angeles.

WILSHIRE BOULEVARD FARMHOUSE, 1909. One of several of John Wolfskill's homes, this one was built in 1885. Later John built another home north of Santa Monica Boulevard, between what is now Selby and Manning Avenues, just before his death in 1913. The house and ranch, known as the Wolfskill Ranch, was later owned by film star Harold Lloyd and became the site of the Los Angeles Mormon Temple.

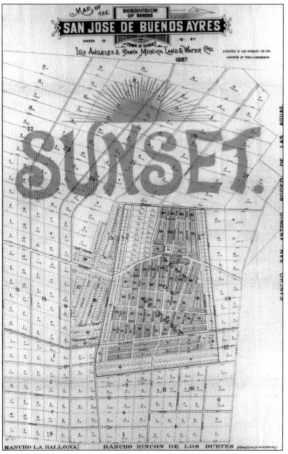

TOWN OF SUNSET, SUBDIVISION MAP, 1887. In 1887, the Los Angeles and Santa Monica Land and Water Company, anticipating a continuing land boom, purchased the San Jose de Buenos Ayres rancho for more than $100 per acre. A townsite was laid out and named "Sunset"—the first use of that name. Lots were surveyed and staked, a railroad was built, and a Grand Hotel was constructed near the intersection of Wilshire and Beverly Glen Boulevards, but the boom did not last, and in 1891, the land quitclaimed back to Wolfskill, who resumed farming it.

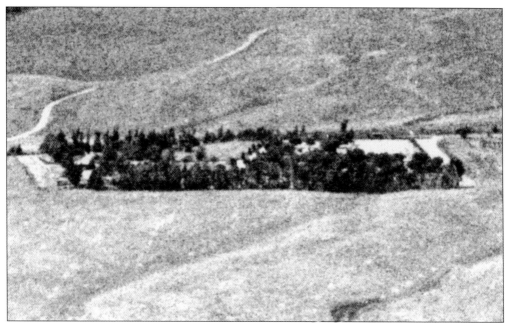

SAWTELLE-SUNSET CEMETERY, 1919. The Sawtelle-Sunset Cemetery was located at what is now 1218 Glendon Avenue, south of Wilshire Boulevard. In 1905, the Sawtelle Cemetery Association was incorporated and took over the original Sunset Cemetery of the defunct Sunset township development. The site was part of land owned by Elizabeth B. Hughes, who came to Los Angeles in 1887 at the time of the Sunset development and establishment of the Sunset Cemetery.

BALLOON ROUTE EXCURSION POSTER, 1912. A Pacific Electric Railway interurban tour circled parts of Southern California early in the 20th century in a figure-eight path. Along the way, Red Car passengers could enjoy the lush landscaping of the soldiers' home in Sawtelle, stroll the beach at Santa Monica, ride gondola cars in Venice, and gather moonstones at Redondo Beach. The 1912 Balloon Route Trolley Trip was advertised to tourists as, "Two dollars worth of pleasure for $1.50. Two days travel reduced to one. Many free attractions en route."

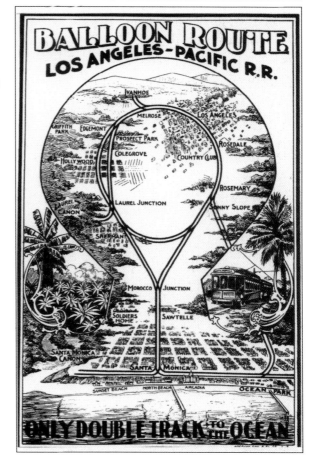

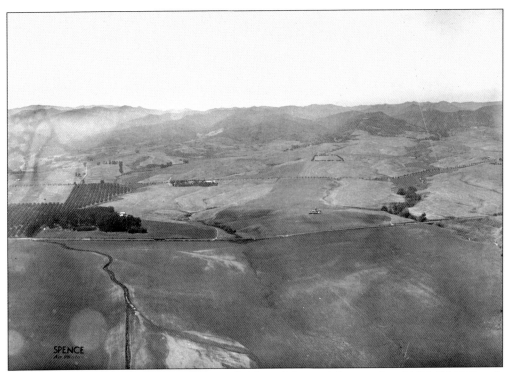

WOLFSKILL RANCHO, 1921. Santa Monica Boulevard (center) bisects the old Wolfskill Ranch property between what is now Westwood Boulevard and Warner Avenue. The site of UCLA is marked by a tree-lined diamond-shaped plot of land in the foothills and the Westwood Village Memorial Park is the tree-lined rectangular property along Wilshire Boulevard, center left. The site of Mormon Temple is marked by one of the Wolfskill Ranch complexes above Santa Monica Boulevard, center.

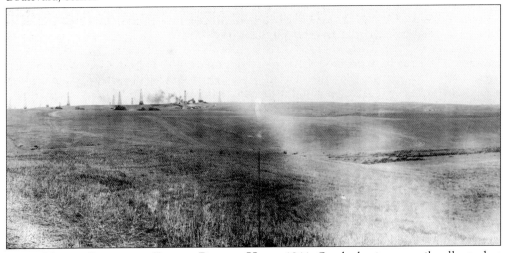

SANTA MONICA BOULEVARD EAST TO BEVERLY HILLS, 1911. On the horizon are oil wells at what is now Century City, at the Beverly Hills border. Portions of the open rolling hills were known for many years as the Wolfskill Ranch. They were sold to individuals and to the Los Angeles Country Club, which opened at its present golf site in 1911. Wolfskill's ranch house and major outbuildings were on the north side of Santa Monica Boulevard, off of what is now Manning Avenue.

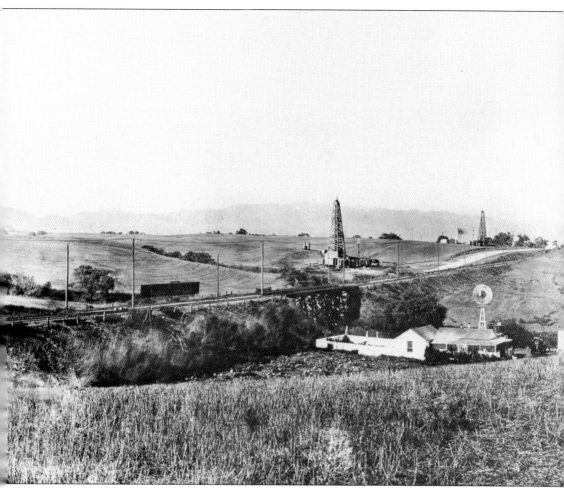

SANTA MONICA BOULEVARD AT BEVERLY GLEN BOULEVARD, 1912. Dr. Fred Lipking, a West Los Angeles dentist whose parents farmed 1,000 acres of the Wolfskill Ranch from 1901 to 1921, remembered his family's farmhouse well. The Lipkings' farmhouse was located on the southwest corner of Santa Monica and Beverly Glen Boulevards, and their property extended south to Pico Boulevard. Four others farmed on Wolfskill property: Ernest Gill, Edward Barnard, Max Geisler, and Cyrus Cole. They farmed where Westwood Village now stands.

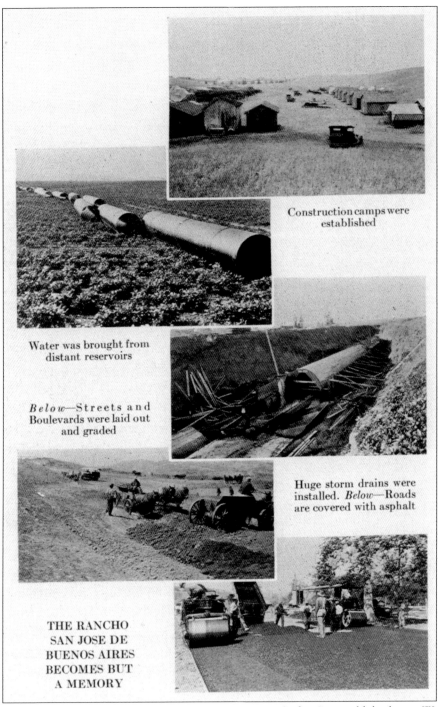

FIRST SUBDIVISION OF THE FORMER WOLFSKILL RANCH, 1922. Arthur Letts sold the former Wolfskill Ranch property south of Wilshire Boulevard to the Janss Investment Corporation in 1922. The Janss Company also took an option on the section north of Wilshire Boulevard. The first subdivision was between Santa Monica and Pico Boulevards, just east of the town Sawtelle and the old soldiers' home borders in 1922. Gradually subdivisions were added as fast as they would sell.

Two

THE LETTS AND JANSS FAMILIES

Arthur Letts died on May 18, 1923, at nearly 61 years of age, after a brilliant career as the founder of the Broadway department store and financier of Bullock's department store. Coming to Los Angeles from England in 1896 with little money, he purchased a bankrupt retail business and, in a few years, built it into the largest in the West, rising prominently in business and social standing.

By 1900, Letts and H. J. Whitley became associates in Hollywood real estate development. Letts actively participated in social life and was host to many dignitaries. A member of the Los Angeles Country Club, he sold the club its current property in 1904. Letts's deals also included the purchase of the Wolfskill Ranch in 1919. This property's development was entrusted to his son-in-law Harold Janss and to Harold's older brother Dr. Edwin Janss, both of whom were experts at subdivision development. Harold had married Arthur Letts's daughter Gladys on April 18, 1911. After the Wolfskill Rancho purchase, Letts thought it would make a wonderful new home for the fledgling Los Angeles campus of the University of California, then located on Vermont Avenue in Hollywood. Arthur Letts Jr. succeeded his father as head of the Broadway Department Store and the family real estate enterprises.

Dr. Peter Janss was born in 1858 in a small village called St. Margaraten in Schleswig-Holstein, at that time part of Denmark and later Germany. He arrived in America in 1870 at age 12 and worked through grammar, business, and medical schools on his uncle's farm. After practicing medicine in Nebraska, Europe, and Chicago, he arrived in California in 1893. He practiced medicine in Los Angeles until 1899, when he entered real estate. He married Emma Stoltenberg in 1879 and had three children: Henrietta (1880), Edwin (1882), and Harold (1889), all born in Nebraska. Harold's marriage to Gladys Letts helped merge the families' real estate interests.

Edwin and Harold Janss joined their father in 1906 in their variously named companies, including the Janss Company, Janss Investment Company, and Janss Investment Corporation. In 1922, the Janss companies acquired the holdings of Arthur Letts in the Rancho San Jose de Buenos Ayres—3,300 acres between the foothills to the north at Sunset Boulevard, Pico Boulevard to the south, the Los Angeles Country Club and Beverly Hills to the east, and the National Soldiers' Home (Veterans' Administration) to the west. The Janss family developed Westwood Hills units until 1955, when they sold their remaining interests in Westwood.

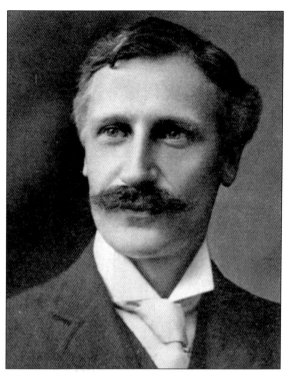

ARTHUR LETTS, 1904. Arthur Letts was born on June 17, 1862, at Holdenby, Northampton, England, as one of ten children of Richard and Caroline Letts, a prominent English family. Arthur left school at 16 years of age to enter the employ of a neighboring dry goods store. Later believing that America offered great opportunities, he left England with his brother and went to Toronto, Canada, where he worked for several years. Los Angeles appealed to him as offering great opportunities, and when he arrived, he immediately got into the retail business.

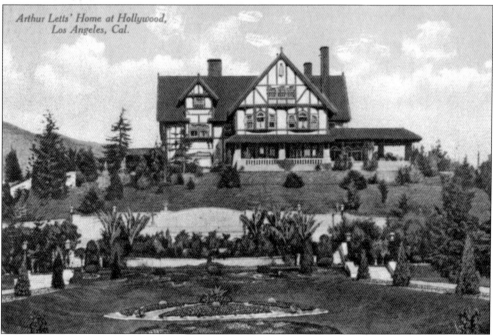

ARTHUR LETTS ESTATE, 1909. By 1904, Letts purchased property in the Los Feliz section of East Hollywood and built a magnificent estate called Holmby House, named after his family's home in Holdenby, England. This Letts Estate was noted for magnificent 30-acre gardens filled with rare and beautiful trees and plants from the world over. Letts amassed a fine art collection, including paintings, marbles, and statues.

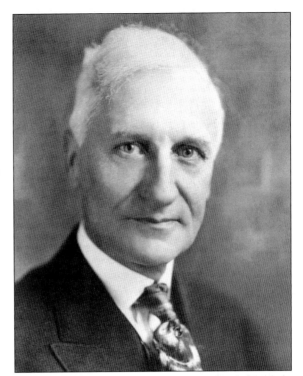

ARTHUR LETTS, 1922. At the time of his death on May 18, 1923, Letts still led an active and vigorous life. More than 6 feet tall, he was a mentor to many and member of the Los Angeles Chamber of Commerce, Realty Board, Hollywood Board of Trade, Federation Club, and various social and country clubs. He was a Master Mason in the Hollywood Lodge, Knight Templar, and Shriner. He also served as a trustee of the Los Angeles State Normal School, the teachers' college that was the forerunner to the Southern Branch of the University of California, which would later become UCLA.

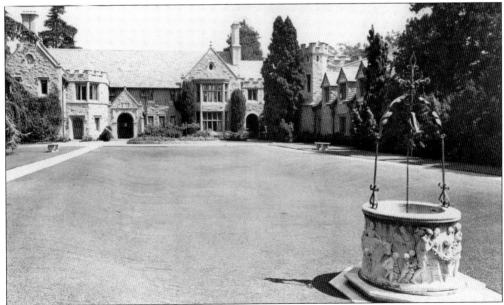

ARTHUR LETTS JR. ESTATE, 1927. The Holmby Hills estate of Arthur Letts Jr. was designed by architect Arthur Rolland Kelly and completed in 1927. The English Tudor mansion at 10236 Charing Cross Road and its magnificent 5.3-acre grounds were a tribute to his fathers's love for the family's traditional English home. In 1971, *Playboy* magazine publisher Hugh Hefner purchased the entire estate for just over $1 million and added more than $1 million in renovations and property expansion, turning it into a playground for adults, including a private zoo, aviary, and grotto, which he renamed Playboy Mansion West.

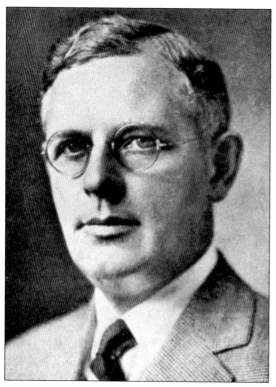

DR. EDWIN JANSS, 1927. Born on July 27, 1882, to Peter and Emma Janss, Edwin Janss attended Los Angeles High School and chose a career in the medical field, studying at the University of Southern California in 1900 and 1901 and Northwestern University Medical School in 1902 and 1903. By 1906, Edwin joined his father in the subdivision business and married Florence Cluff on September 12, 1912. They had three children: Patricia, Edwin Janss Jr., and William Cluff Janss. Edwin joined the Navy Medical Corps during World War I.

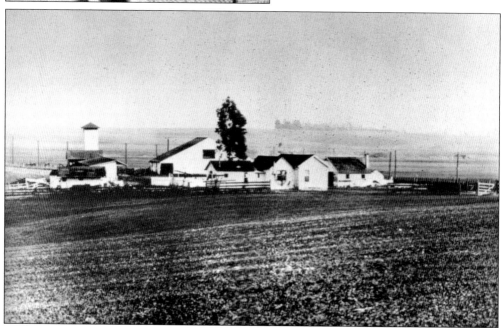

JANSS RANCH, 1922. The Janss Ranch was originally one of the old Wolfskill Ranch complexes, located at what is now the northwest corner of Midvale and Massachusetts Avenues, one block northwest of Westwood and Santa Monica Boulevards. During the development of Westwood Hills, all the Wolfskill Ranch buildings and other remaining farm buildings on the rancho were demolished.

HAROLD JANSS, 1927. Born in Grand Island, Nebraska, on August 2, 1889, Harold Janss graduated from Princeton and later the University of California at Berkeley. The younger of the two Janss brothers, he married Gladys Letts, daughter of Arthur Letts, on April 18, 1911. They had three children: Elizabeth, Virginia, and Gladys. With his marriage, the two great real estate families of Westwood were joined.

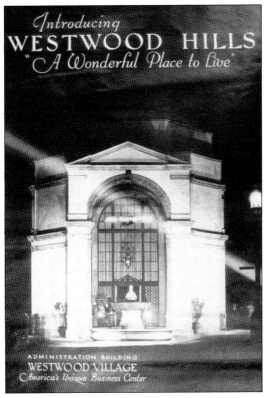

WESTWOOD HILLS SALES BROCHURE, 1929. The Janss Investment Corporation's original headquarters in Westwood Village was located in the landmark Janss Dome Building, which they constructed at the intersections of Westwood Boulevard, Broxton Avenue, and Kinross Avenue. Over the years, the building has been the home to Bank of America, Glendale Federal Savings, Oakley's Barber Shop, Wherehouse Records, Contempo Casuals, Eurochow Restaurant, and Yamato Restaurant. When the Janss Dome Building opened in 1929, the second floor also housed the first men's dormitory for UCLA students.

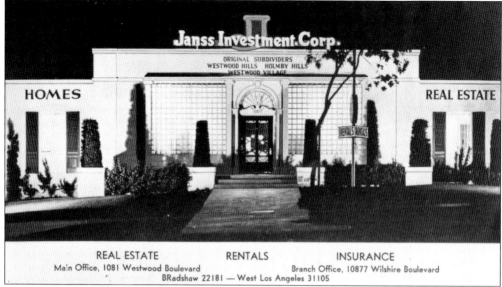

JANSS INVESTMENT REAL ESTATE OFFICE, 1938. Expansion of the Janss Company since 1929 resulted in district offices around the Westwood area. In Westwood Village, the Janss Company maintained several general and sales offices. This one was a branch office located at 10877 Wilshire Boulevard on the northeast corner of Glendon Avenue, later the site of Ships Coffee Shop and now the Center West office tower.

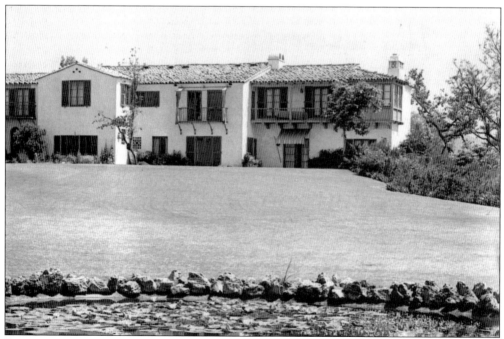

EDWIN JANSS ESTATE, 1925. The estates of brothers Edwin and Harold Janss were the first two to be built in Holmby Hills in 1925, when the area was opened for sales. Harold's estate was located at 10060 Sunset Boulevard, opposite Carolwood Drive—a stately 20-room Spanish-style mansion designed by Gordon B. Kaufmann on 4.5 acres. Edwin built his Tudor-style estate nearby at 375 North Carolwood Drive. Both Janss estates have since been demolished.

Three

Original Westwood Tract and Fox Hills Units

The first Westwood subdivision was started between Santa Monica and Pico Boulevards, just east of Sawtelle and the old Soldiers' Home borders in 1922. Subdivisions were added as fast as they would sell. A Janss advertisement on October 22, 1922, proclaimed Westwood as "The First Opportunity for Big Profits." Following this, Janss subdivided acreage between Santa Monica and Wilshire Boulevards, selling it all. In this section, 300 acres were subdivided in the easterly end and allowed Janss employees and executives the right to subscribe and participate. To promote sales, the company constructed many houses and business buildings.

Orginally, the Janss Corporation intended to call its new development simply "Westwood." But upon discovery that a lumber town in Northern California with the same name existed, the Janss brothers tacked on "Hills" to differentiate their new subdivision.

In early 1923, the Janss Company concentrated on developing the area between Santa Monica and Pico Boulevards. The first house in this unit was located at 1901 Kelton Avenue on the corner of La Grange Avenue. The property along Westwood Boulevard, south of Santa Monica Boulevard, was to be a business area. In May 1923, newspapers announced that the Fox Film Corporation was moving to Westwood. The studio site's 450 acres were earmarked as a location ranch.

In September 1927, the Janss Corporation created a golf course adjacent to the Fox Movietone Studio property between Santa Monica and Pico Boulevards, bordering on Beverly Hills. This "pay-as-you-play" course was named the Westwood Public Golf Course, sponsored by a consortium of financiers operating as Fairways, Inc. Max Behr was the architect, and the course opened on November 11, 1927. After a decade, Fox Studios annexed part of the course area onto the backlot.

In 1931, an announced shortage of homes in Westwood Hills advised, "Choose your home before the crowd comes." One of the showplace homes open for inspection was located at 10465 Wilkins Avenue. In another advertisement, a Spanish bungalow at 2055 Midvale Avenue was selling for $7,850 with two tile baths, unit heat, and electric refrigeration on a 50-foot-by-135-foot lot.

A major development in what had been the Fox Hills Unit was announced by 20th Century-Fox president Spyros P. Skouras in 1957. Skouras said that a new "city" would be developed by the real estate division of 20th Century-Fox, designed by the architectural firm of Welton Becket Associates in the area northeast of the studio on Pico Boulevard. The plan was to build a lavish residential area and shopping center on 280 acres of land south of Santa Monica Boulevard on the studio's backlot. This new development would be called "Century City."

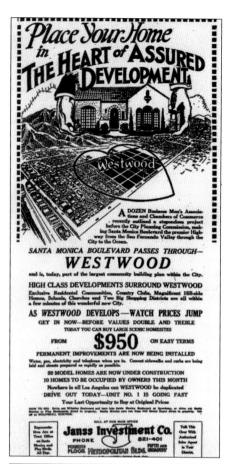

ORIGINAL WESTWOOD UNIT ADVERTISEMENT, 1923. A progress report on the original Westwood Unit in February announced development surrounding the Westwood area, including new communities, country clubs, hillside homes, schools, churches, and two big shopping districts. "Permanent improvements are now being installed," the report stated. "Water, gas, electricity, telephone wires are in. Cement sidewalks and curbs are being laid and streets prepared as rapidly as possible."

SANTA MONICA BOULEVARD AT KELTON AVENUE, 1923. Janss Company representatives, looking east, review plans of the proposed widening of Santa Monica Boulevard at the future Kelton Avenue intersection. The original Westwood Unit opened in early 1923 included the Fox Hills Unit on the eastern portion of the original tract border, adjacent to the Fox Film Corporation. The borders of the Original Westwood Unit were Santa Monica Boulevard to the north, Pico Boulevard to the south, Beverly Glen Boulevard to the east, and Sepulveda Boulevard to the west.

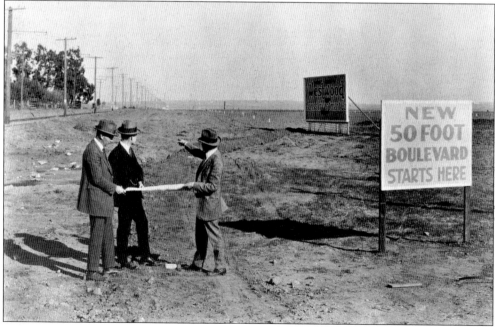

FIRST DIVISION OPEN HOUSE ANNOUNCEMENT, 1922. The opening of the Original Westwood Unit on October 22, 1922, was a success, as several thousand people visited. The Janss Investment Company previously announced in the press that a "$7 Million transaction through which we [Janss] acquired the last remaining large tract of land between Los Angeles and Santa Monica was completed."

WESTWOOD HILLS DEVELOPMENT, NORTH FROM PICO BOULEVARD, 1929. By 1929, the Westwood Hills development was underway with many units under construction while open houses and sales were conducted. At left is Westwood Boulevard ending at the future Westwood Village at Wilshire Boulevard. Santa Monica Boulevard transects Westwood Hills in the center with Beverly Glen Boulevard winding north at the right. UCLA, under construction, is located at the top center.

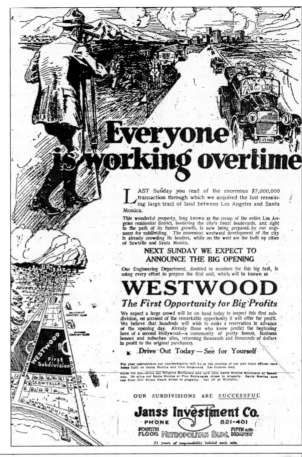

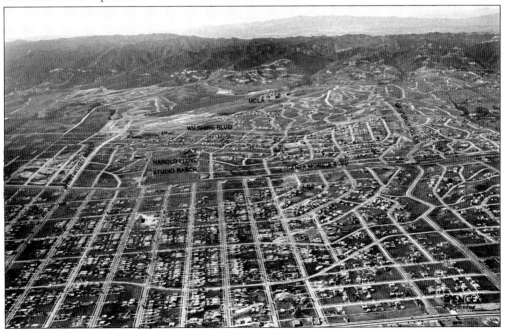

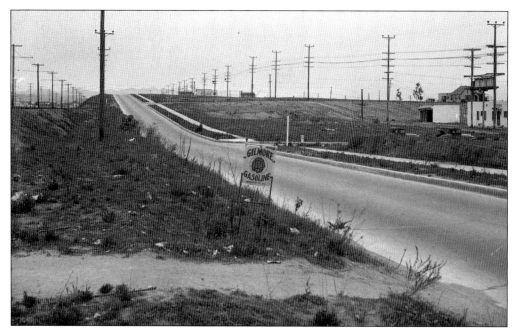

SANTA MONICA BOULEVARD AT PROSSER AVENUE, 1931. Looking east along Santa Monica Boulevard, Prosser Avenue is seen in the center of the photograph on the south side of the street, four blocks east of Overland Avenue. This view is of the north boundary of the Original Westwood Unit. No lots were sold yet fronting Santa Monica Boulevard. The Pacific Electric Railway right-of-way is seen at left. The "Red Cars" were the transportation link between Los Angeles, Beverly Hills, and Santa Monica.

FRENCH-STYLE HOME, ORIGINAL WESTWOOD UNIT, 1939. Located at 2034 Manning Avenue (at Mississippi Avenue), this was one of the typical homes built in the center of the Original Westwood Unit. The house was being used as a residence and office of Dr. Marvel Beem, M.D., who later moved his practice to 10841 Lindbrook Drive in Westwood Village.

JANSS INVESTMENT COMPANY ADVERTISEMENT, 1923. This advertisement announced, "New Studio Sites are in the Heart of Westwood!" and promoted Westwood as a western version of Hollywood to attract film studios to invest in Westwood real estate. Though Fox Studios, Harold Lloyd Corporation, and Christie Film Company took the bait, the Janss development strategy of creating a "Second Hollywood" faltered; luring the UCLA campus became "Plan B."

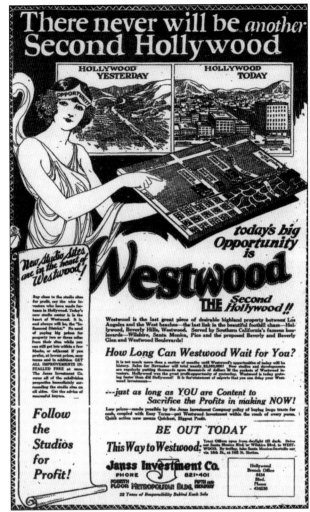

WESTWOOD BOULEVARD, 2000 BLOCK, 1963. This view looks south toward Westwood Boulevard on Mississippi Avenue. Since the 1930s, South Westwood Boulevard became the business district for both the Original Westwood and Westwood Prosperity Units. It was not until the 1960s that most of the boulevard lots were filled with businesses. In 1963, some of those in the block were Talk O' the Town Dry Cleaning, Shipley Plumbing, China Boy Hand Laundry, a golf shop, and West Poultry.

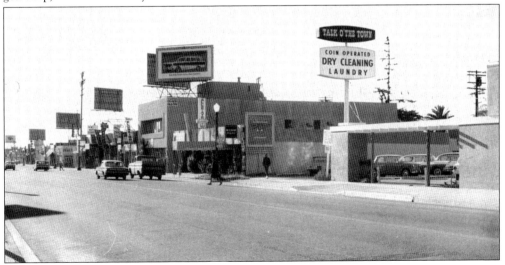

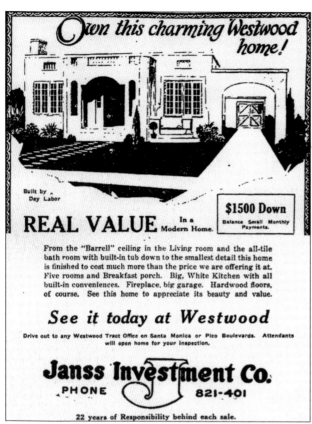

JANSS ADVERTISEMENT, 1923. The Janss Investment Company built model homes in most of its development units to help sell the idea of living in the new Westwood Hills community. Janss was a full-service company. It employed its own achitects and engineers, did all its own public improvements and grading, planned parks and schools, sold lots, built homes, provided financing, and sold title insurance.

ORIGINAL WESTWOOD UNIT, 1946. The view here looks north with Veteran Avenue at far left, Westwood Boulevard at center, Santa Monica Boulevard at top center, and Olympic Boulevard at the bottom. Ralph Waldo Emerson Junior High School can be seen at top right. Note that much of the Original Westwood Unit had houses by 1946.

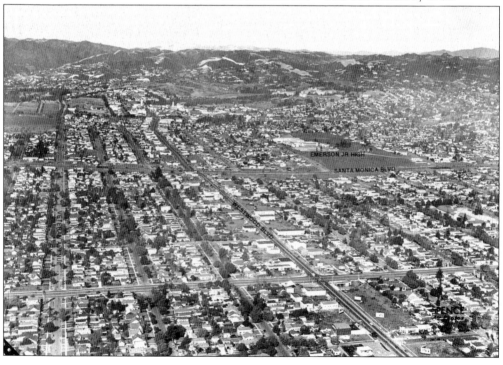

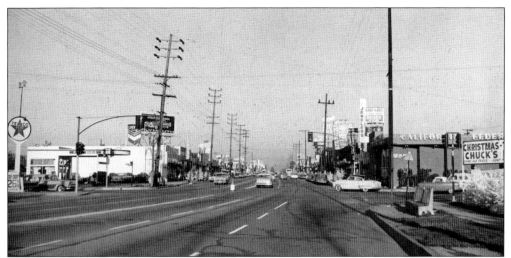

PICO BOULEVARD AT OVERLAND AVENUE, 1956. Looking east along Overland Avenue, the north side of Pico is the business district connected to the Original Westwood Unit development. The south side of Pico is in the Rancho Park District. The Westside Pavilion occupies the south side of Pico today.

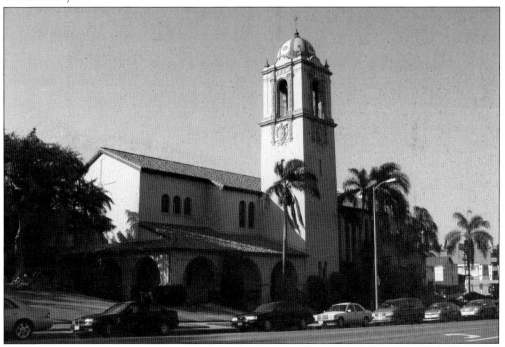

ST. TIMOTHY CATHOLIC CHURCH, 2009. St. Timothy Catholic Church was established in 1943 at 10425 West Pico Boulevard (at Beverly Glen Boulevard) to serve the Original Westwood Unit to the east and the Rancho Park and Cheviot Hills area. To the south, Parish Hall is actually the first church built by parishioners in 1946, designed by architect Harold Gimeno. In the building process, an antique Spanish altarpiece was obtained and installed. Not long after this, construction began on a new permanent facility. Construction of the main church began in January 1949 and was completed in time for Christmas, when the first Mass was celebrated in the permanent church.

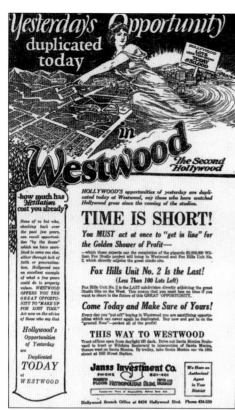

FOX HILLS UNIT ADVERTISEMENT, 1923. This advertisement announced, "Unit 1-Fox Hills of Westwood nearly sold out—engineers working early and late to prepare Unit 2 for the market." Fox Hills Unit No. 1 is approximately the land south of today's Olympic Boulevard to Pico Boulevard. Fox Hills Unit No. 2 is north of Olympic Boulevard to Santa Monica Boulevard. Both were adjacent to the Fox Film Corporation studio, which inspired the Fox Hills name.

FOX HILLS REALTY COMPANY (JANSS INVESTMENT CORPORATION), 1931. This aerial view facing north from Pico Boulevard shows, at left, the Fox Hills Unit, Fox Film Corporation Unit, and Fox Hills "un-subdivided" area, which became the Fox Hill Realty–operated Westwood Public Golf Course and the adjacent Pitch and Putt Golf Course in 1927. In later years, Fox Studios leased this area for backlot activities. For many years films were produced among the oil wells leased from the Janss Company.

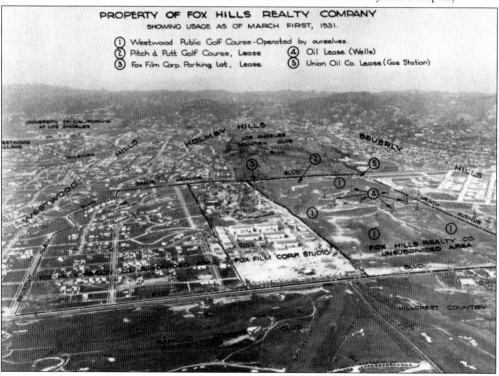

FOX HILLS UNIT NO. 2 ADVERTISEMENT, 1923.
In October 1923, Fox Hills Unit No. 2 lots sold quickly. "Fox Hills Unit No. 2 is the last subdivision directly adjoining the great studio site on the east," the ad read. "Completion of the gigantic $2 million William Fox Studio project will bring Westwood and Fox Hills Unit No. 2, which adjoins the great studio site."

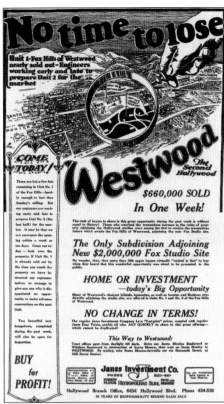

FOX HILLS UNIT, 1936. Looking south, this view takes in the Fox Hills Unit with the 20th Century-Fox Studios at left and Fox Hills Drive adjacent to it. In the top center is Olympic Boulevard and Bellwood Avenue as they fork into separate streets through a small valley to form a continuation of Olympic Boulevard. The area was cleared, and the modern Olympic Boulevard joined the eastern and western portions of the boulevard as it is today. Beverly Glen Boulevard is at far right, twisting south.

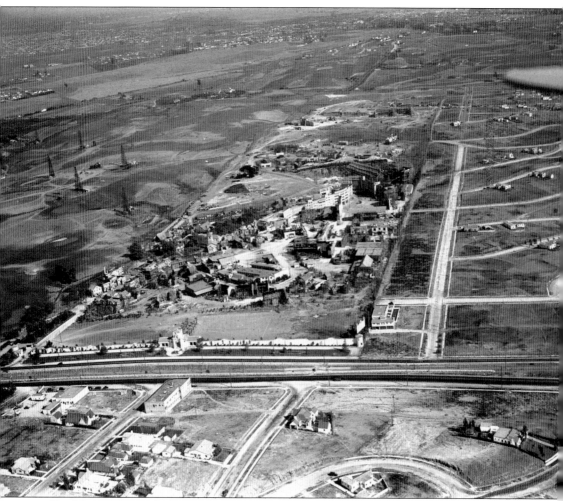

Fox Hills Studio South, 1928. The Fox Hills Unit was originally bounded by Santa Monica Boulevard to the north, Pico Boulevard to the south, Beverly Hills to the east, and Beverly Glen Boulevard to the west. The Janss Company had plans for this unit to be one of the adjacent community developments attached to the Original Westwood Unit on the east side. When the Fox Hills Unit was ready for sale in 1923, the Fox Film Corporation purchased a parcel in between the then undeveloped Fox Hills Unit and the Westwood public golf course. The southern portion of the Country Club Unit, now known as Comstock Hills, is at the bottom of the photograph at Santa Monica Boulevard and Comstock Avenue (right).

Westwood Public Golf Course, 1927 (Opposite Page). The north section of the "Undeveloped Fox Hills Unit," where oil wells and golfing existed side by side for many years, is seen here looking east with Santa Monica Boulevard at left, the city of Beverly Hills and Beverly Hills High School at the top, and some of the Fox Hills Studio backlot at the bottom of the photograph. The Janss Company created the Westwood Municipal Golf Course in 1927, with its clubhouse entrance on Santa Monica Boulevard.

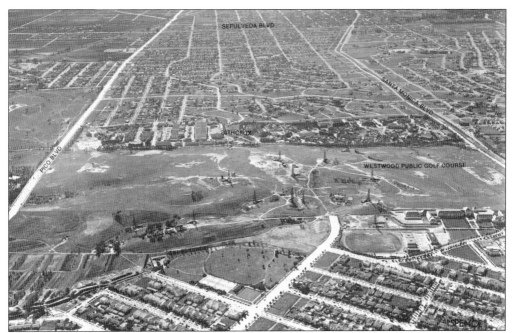

ORIGINAL FOX HILLS AND ORIGINAL WESTWOOD UNITS, 1936. Looking west along Pico Boulevard at left, the Beverly Hills border is at bottom with Beverly Hills High School at bottom right. The Fox Hills undeveloped tract with the oil leases on it became known as the Westwood Public Golf Course. At center is 20th Century-Fox Studios, spanning from Santa Monica Boulevard on the right and the Westwood Public Golf Course (center) to the Original Westwood development west of Fox Studios to Sepulveda Boulevard and to Pico Boulevard on the left.

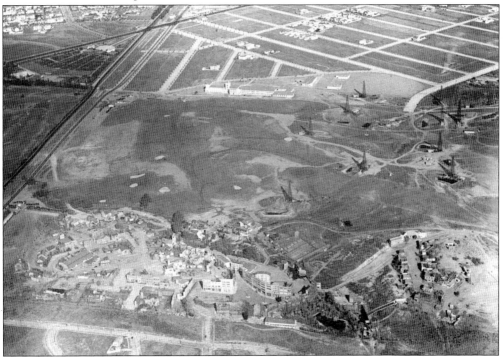

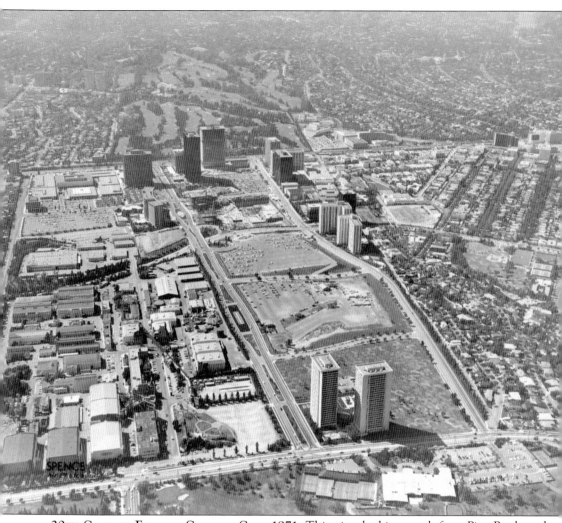

20TH CENTURY-FOX AND CENTURY CITY, 1971. This view looking north from Pico Boulevard shows the main Fox Studios lot at bottom left and the Century City development at center and above. Construction began on Century City in 1961 after a convergence of 1957 developing partners, including ALCOA (Aluminum Company of America) and 20th Century-Fox Real Estate Development. Century City was developed on land that had been the backlot of 20th Century-Fox. After suffering a string of expensive flops culminating in the box-office disaster *Cleopatra*, Fox sold some 180 acres to developer William Zeckendorf. The developers hired the architectural firm of Welton Becket Associates to master-plan the development, which was unveiled in 1957. The first building, Century City Gateway West, opened in 1963 at the southwest corner of Santa Monica Boulevard and Avenue of the Stars. It was followed the next year by the 19-story Century Plaza Hotel, designed by Japan's Minoru Yamasaki, who also designed the World Trade Center's Twin Towers in New York City.

Four

WESTWOOD PROSPERITY AND COUNTRY CLUB UNITS

The Westwood Prosperity Unit was initiated by the Janss Investment Company in 1924, offering homesites as well as "Choice Wilshire Income Frontage and Santa Monica Boulevard Business Lots." The boundaries of the Prosperity Unit were Wilshire Boulevard to the north, Santa Monica Boulevard to the south, Beverly Glen Boulevard to the east, and Sepulveda Boulevard to the west. Schools and churches were planned among the neighborhoods, and the film industry was courted to Santa Monica Boulevard, where an envisioned "Second Hollywood" would blossom.

Before the development of Westwood Hills, the Sunset Cemetery was located at what is now 1218 Glendon Avenue, south of Wilshire Boulevard. In 1905, the Sawtelle Cemetery Association was incorporated and took over the cemetery of the failed Sunset boomtown. The site was owned by Elizabeth B. Hughes, who came to Los Angeles in 1887 during the "Sunset" development.

Fairburn Avenue Elementary School was constructed at 1403 Fairburn Avenue as the first school in the unit, completed in 1926. Eleven years later, Ralph Waldo Emerson Junior High School opened on 10 acres of the former Harold Lloyd studio grounds. In September 1936, construction of various apartment buildings was announced for Beverly Glen Boulevard, south of Wilshire Boulevard. One of them was described as an "Early American triplex-type" apartment building at 1432 Beverly Glen Boulevard. On April 13, 1946, the Church of Jesus Christ of Latter-day Saints announced its largest construction project ever. "The Temple, a ceremonial building like its Mormon temple in Salt Lake City," according to the *Los Angeles Times*, "will be erected on the old Harold Lloyd studio tract of 22.5 acres with a 1,000 foot frontage on Santa Monica Boulevard, just east of Westwood Boulevard."

Sinai Temple, originally located in downtown Los Angeles, relocated to Westwood in 1960 at the southwest corner of Wilshire and Beverly Glen Boulevards. Designed by Sidney Eisenshtat, Sinai Temple has been a Westwood landmark for nearly half a century. The new sanctuary opened in 1960. The first school facilities and Kohn Chapel were opened in 1969. Another expansion program was completed in 1998, making Sinai Temple one of the more architecturally striking landmarks in the Wilshire Corridor. In the 1960s, the Sephardic Temple Tifereth Israel bought land on the southwest corner of Wilshire Boulevard and Warner Avenue. The style of this temple was adapted from architecture in Jerusalem and opened in 1975.

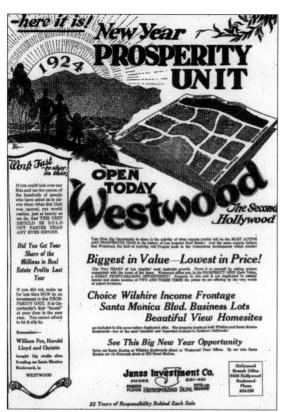

WESTWOOD PROSPERITY UNIT ADVERTISEMENT, 1924. At the beginning of January 1924, an announcement to the press about the opening of sales season for the Prosperity Unit said, "Here it is! New Year Prosperity Unit open today, Westwood, The Second Hollywood." Brothers Edwin and Harold Janss witnessed the success of the Hollywood real estate development fueled by the motion picture industry. They hoped to replicate that pattern by marketing their subdivision in Westwood Hills as the next logical place for studios to expand or relocate.

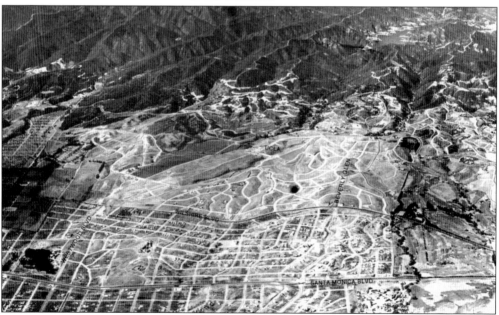

WESTWOOD HILLS DEVELOPMENT, 1927. This aerial view shows the ongoing development of Westwood Hills in November 1927. The Prosperity Unit is seen at the lower section of the photograph, showing Santa Monica Boulevard at the bottom and Wilshire Boulevard in the center. At this time, the Prosperity Unit began to fill with homes on the hilly landscape.

WESTWOOD PROSPERITY UNIT ADVERTISEMENT, 1924. By January 20, 1924, the Prosperity Unit was selling out quickly. The original Janss strategy of promoting their Westwood Hills development as "The Second Hollywood" is seen in this advertisement. The idea of Westwood serving as the future home of the new UCLA campus had not yet crystalized.

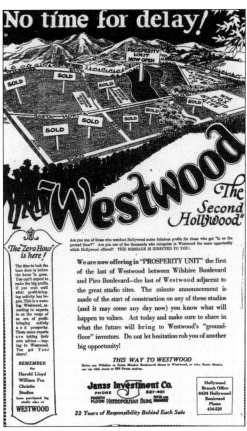

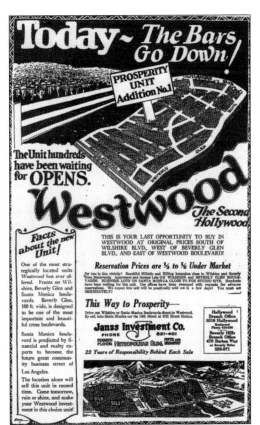

WESTWOOD PROSPERITY ADVERTISEMENT, 1924. In February, advertisements boasted, "Prosperity Unit Addition No. 1 is the last opportunity to buy in Westwood at original prices south of Wilshire Boulevard, west of Beverly Glen Boulevard and east of Westwood Boulevard." The Janss brothers appealed to potential investors that buying a lot in their new Westwood subdivision was "the way to prosperity."

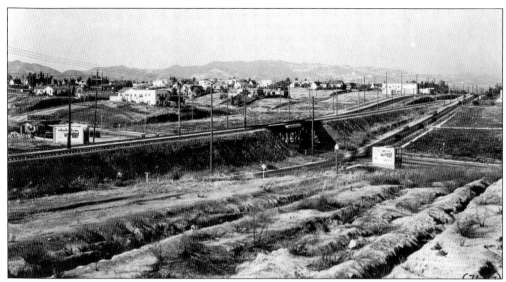

COUNTRY CLUB UNIT, SOUTHERN SECTION, 1927. The view here looks northeast along Santa Monica Boulevard at Beverly Glen Boulevard (center) and with Pandora Avenue (obscured). The southern section of the Westwood Country Club Unit began filling with homes by 1927. The two-story building at far right was the Country Club Market, which was located on the northwest corner of Club View Drive and Santa Monica Boulevard. It served the new neighborhood across from the Fox Hills Studio, now known as Comstock Hills.

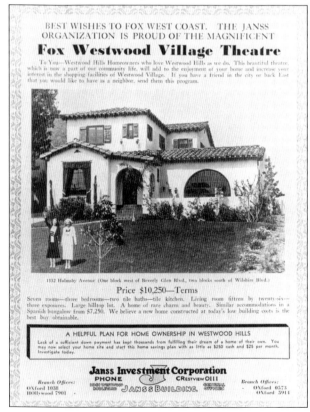

JANSS INVESTMENT CORPORATION ADVERTISEMENT, 1931. This August 1931 advertisement appeared on the back page of the dedication program for the new Fox Westwood Village Theatre and announced, "Today's Price $10,250.00 Terms! 1332 Holmby Avenue house. The living room in this lovely Janss home is 15x26 feet with three exposures. French windows open on a paved terrace, with natural rock-pool and a beautiful studio window overlooking the desert garden. There are three bedrooms, two tiled baths and a cheerful yellow tiled kitchen."

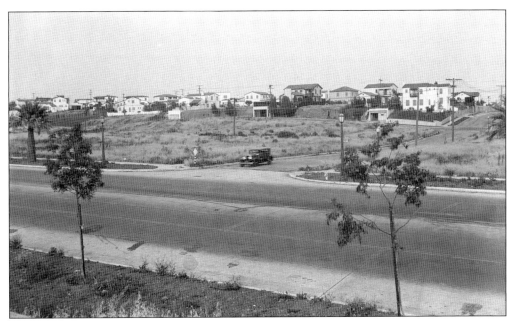

WILSHIRE BOULEVARD AT THAYER AVENUE, 1931. Looking southeast across Wilshire Boulevard to Thayer Avenue in the Prosperity Unit, one can see at least 20 homes on Thayer and Pandora Avenues. This stretch of Wilshire Boulevard was all dirt lots.

LITTLE SANTA MONICA BOULEVARD AT PROSSER AVENUE, 1931. This vantage point looks west along the original portion of Santa Monica Boulevard and the Pacific Electric right-of-way at right that runs through the entire Westwood Hills development. This was two years after the UCLA campus opened and two years after the Wall Street crash and the onset of the Great Depression.

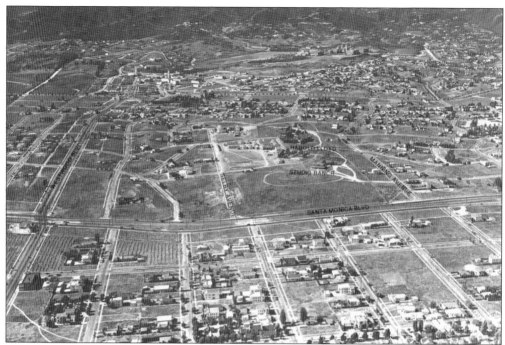

WESTWOOD PROSPERITY UNIT, 1935. This northward view shows Santa Monica Boulevard and Selby Avenue at center, Westwood Boulevard at left, and Manning Avenue at right. The Harold Lloyd Studio Ranch can also be seen in the center adjacent to the temporary buildings of Ralph Waldo Emerson Junior High School.

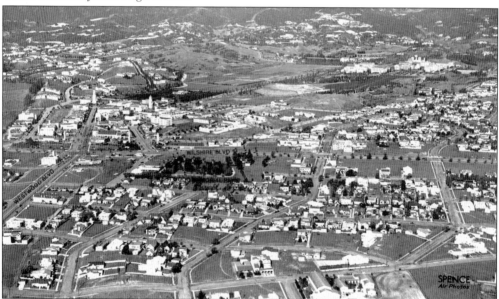

WESTWOOD VILLAGE AND PROSPERITY UNIT, 1938. A northward view depicts Wilshire Boulevard at center, Westwood Boulevard at left, and Selby Avenue at right. In the center grove of trees is Westwood Memorial Park cemetery, seen here on January 20, 1938. In 1921, a crematorium expert, Frank B. Gibson, purchased the former Sunset Cemetery and operated it under the name Westwood Memorial Park.

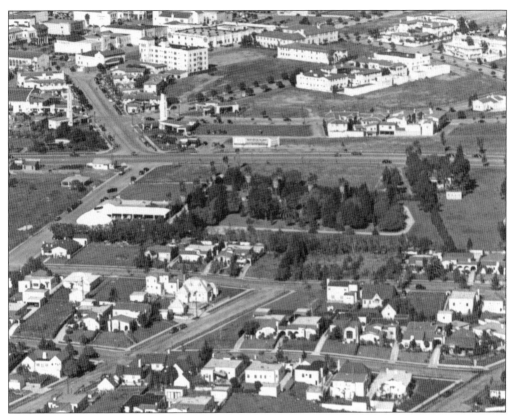

WESTWOOD MEMORIAL PARK CEMETERY, 1938. Seventy years after this photograph was taken, this cemetery was hidden from street view, located in the middle of the block created by Wilshire Boulevard to the north, the homes on Wellworth Avenue to the south, the future Westwood Presbyterian Church to the east, and Glendon Avenue to the west.

WESTWOOD CEMETERY, 1931. Looking south at Wilshire Boulevard and Glendon Avenue at the southeast corner, the Westwood Memorial Park Cemetery sign can be seen. The same corner would be the site of the Westwood Place office tower at 10866 Wilshire Boulevard, the AVCO office tower at 10850 Wilshire Boulevard, and the AMC/AVCO Center 4 Theatres at 10840 Wilshire Boulevard. In 1959, Pierce Brothers Mortuary Company purchased the cemetery.

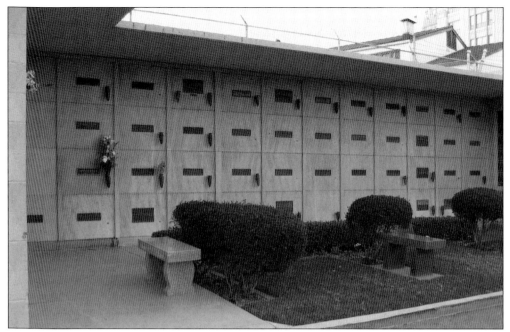

WESTWOOD VILLAGE MEMORIAL PARK, 2009. Beginning in 1962, this tiny cemetery became famous for its VIP resting places, including those of Marilyn Monroe (whose crypt is at left with memorial flowers), Dean Martin, Darryl F. Zanuck, Natalie Wood, Jack Lemmon, Frank Zappa, Mel Torme, and Farrah Fawcett. The cemetery was declared Los Angeles City Historic-Cultural Monument No. 731 in 2002.

WESTWOOD BOULEVARD, NORTH, 1946. By 1946, the Westwood Hills area was a thriving community with all the amenities—a unique "town" within the Los Angeles area. Westwood Boulevard was already an extension of the Westwood Village business district that stretched south to Pico Boulevard.

CREST THEATER, 1963. The UCLAN Theater opened in December 1940 as a live theater built by Frances Seymour Fonda, the second wife of Henry Fonda and the mother of Jane and Peter Fonda, at 1262 Westwood Boulevard. Designed by architect Arthur W. Hawes as a 500-seat auditorium, the theater was converted into a newsreel house during World War II and then became an art house cinema showing foreign films and later a first-run feature house. South of the Crest at Westwood Boulevard and Wellworth Avenue was Bliss & Paden Chevrolet. In the distance is the Kirkeby Center tower at the northeast corner of Wilshire and Westwood Boulevards, now the Occidental Petroleum headquarters.

WESTWOOD BOULEVARD AT ROCHESTER AVENUE, 1963. The Westwood Boulevard business district, which ran south from Westwood Village to Pico Boulevard, catered to the large community that settled in the Original Westwood and Westwood Prosperity Units for more than four decades.

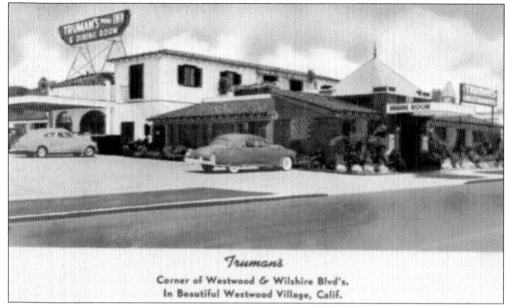

TRUMAN'S DRIVE INN, 1946. Located on the southeast corner of Westwood and Wilshire Boulevards, this restaurant was a Westwood landmark into the 1960s. Originally built in the early 1930s as the Hi-Ho Cafe, it became Mrs. Gray's Inn by the mid-1930s. By 1950, Truman's Drive Inn and Dining Room became the new landmark until it was replaced by a high-rise office building in 1969.

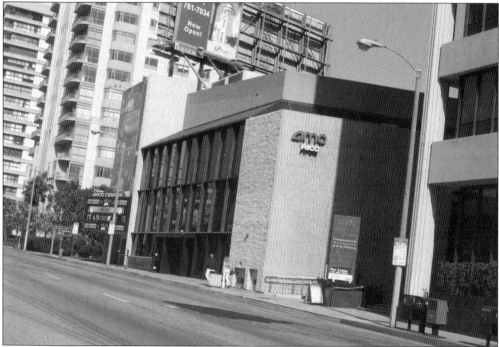

AMC AVCO CENTER 4, 2009. The AVCO Center Cinemas at 10840 Wilshire Boulevard opened as a triplex theater on May 24, 1972. In May 1974, General Cinema took over the theater and renamed it General Cinema's AVCO Center Cinema. The theater property was owned by the next-door AVCO office building, and both buildings fronted the Westwood Village Memorial Park.

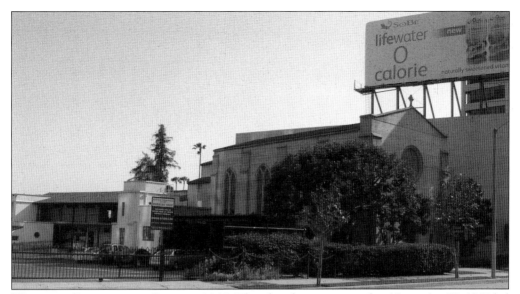

WESTWOOD PRESBYTERIAN CHURCH, 2009. This church was organized on November 23, 1947, led by the Reverend Cecil Hoffman, Presbyterian campus minister at UCLA. In 1949, the Presbytery purchased a lot at 10822 Wilshire Boulevard, east of Glendon Avenue. The congregation moved a former Janss satellite office building from across the street to their new property as a new temporary chapel. This building (now the church's fellowship building, Hoffman Hall) was retrofitted as a temporary chapel. The first worship service was held in July 1950.

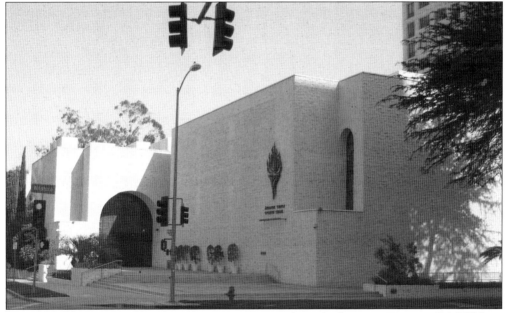

SEPHARDIC TEMPLE TEFERETH ISRAEL, 2009. Ground was broken in 1970 at 10500 Wilshire Boulevard, the southwest corner of Wilshire Boulevard and Warner Avenue by the Sephardic Jewish community and Brotherhood of Los Angeles for a beautiful temple made of Jerusalem stone. By 1975, the congregation moved from its original Los Angeles location to the Westwood site. In September 1981, the sanctuary was dedicated. On October 1, 1987, King Juan Carlos I and Queen Sofia of Spain visited the temple.

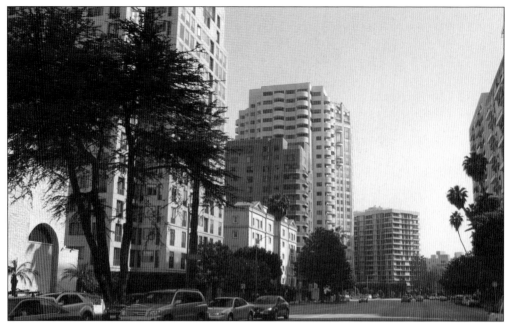

WILSHIRE-WESTWOOD CORRIDOR, WEST, 2009. The development of Wilshire Boulevard property in Westwood began in the last quarter of the 1930s with small apartment house construction. In 1941, new apartments were built, adding to the boulevard's density. The boom began in the late 1950s with high-rises on the northwest and northeast corners of Wilshire and Beverly Glen Boulevards.

WILSHIRE-WESTWOOD CORRIDOR, EAST, 2009. Beginning in the 1970s, numerous high-rise luxury condominium and apartment buildings were constructed along the Wilshire Corridor, first marketed as "The Golden Mile" and later "The Platinum Mile." By 1997, the colossal towers included The Wilshire, a 28-story, Art Deco–style edifice. In 2009, The Carlyle, a 24-story crescent-shaped luxury condominium, and the 21-story Beverly West were the last high-rises permitted on the Wilshire-Westwood Corridor.

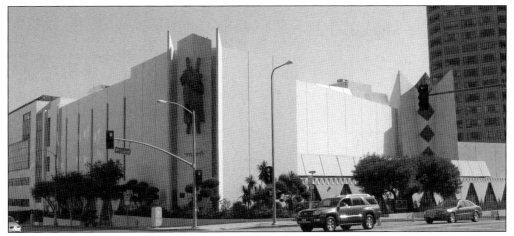

SINAI TEMPLE, 2009. In 1906, Sinai Temple was established as the first Conservative Jewish congregation in Southern California. From 1906 to 1925, the temple was located just west of downtown Los Angeles and later moved to the Mid-Wilshire district. The westward movement of the Jewish community led the congregation to purchase property at 10400 Wilshire Boulevard on the southwest corner of Beverly Glen in 1956. In 1960, services were held in the new sanctuary.

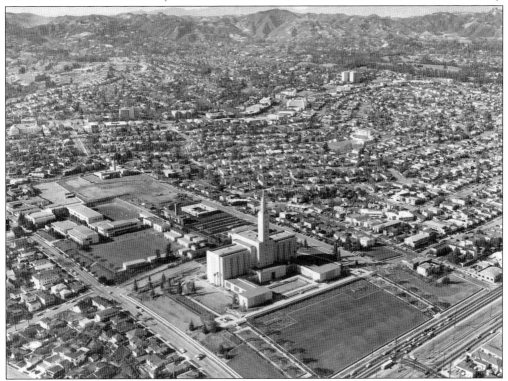

MORMON TEMPLE, 1955. The Church of Jesus Christ of Latter-day Saints bought part of the Harold Lloyd Studio Ranch in 1937, and a monumentally scaled Los Angeles temple was dedicated there with 12,000 people in attendance on March 11, 1956, during a four-day celebration. Edward O. Anderson was the architect of this edifice designed in a modernized classical style. The hilltop site is beautifully landscaped, with manicured lawns, trees, and shrubs forming a completely unified composition.

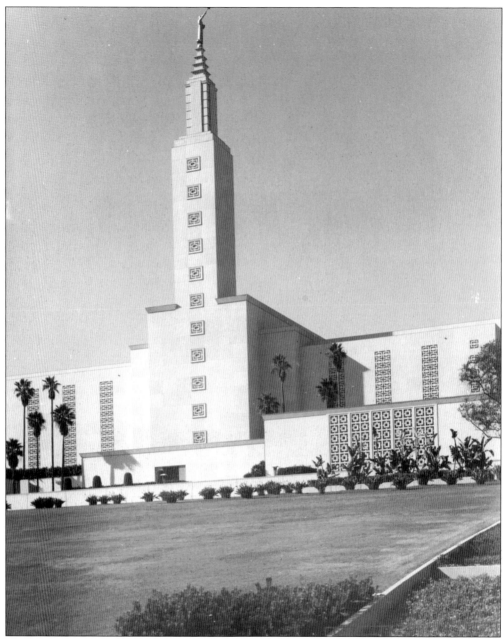

MORMON TEMPLE, 1960. The planning for the construction of the Los Angeles Mormon Temple in Westwood began in 1952, and the result was the largest Westwood landmark for miles around when it opened. Located at 10777 Santa Monica Boulevard at Selby Avenue, the site is on the exact location of the last Wolfskill family home, owned by Harold Lloyd until the church purchased the property in 1937. The temple contains an important genealogical research center. A 15-foot-high gold-leaf statue of the Angel Moroni blowing his trumpet graces the summit of the soaring tower, which reaches a height of 257.5 feet.

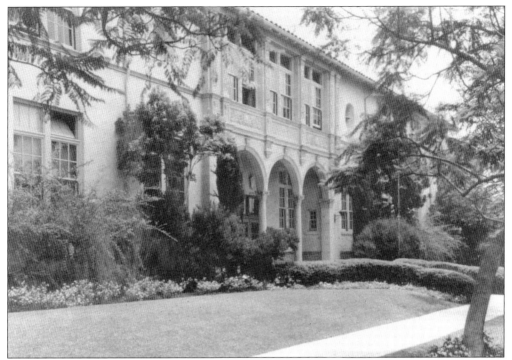

WESTWOOD GRAMMAR SCHOOL, 1950. Located at 2050 Selby Avenue, the school opened in November 1925, with Warner Brothers canine star Rin Tin Tin and his trainer Lee Duncan attending. Facilities included a library, cafeteria, auditorium, and classrooms. More recently, the school became known as Westwood Charter School.

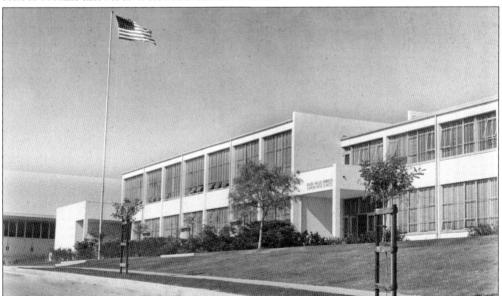

RALPH WALDO EMERSON JUNIOR HIGH SCHOOL, 1941. Established on the old Harold Lloyd property in 1935 at 1650 Selby Avenue, students were taught in temporary wooden bungalows until a more substantial school could be built. Renowned modernist architect Richard Neutra, affiliated with UCLA, designed the 1937 school buildings in his signature International Style.

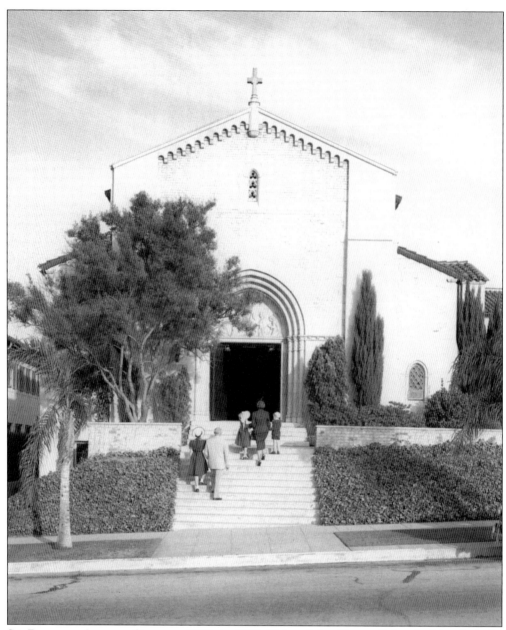

ST. PAUL THE APOSTLE CHURCH, 1950. In 1928, Bishop John Cantwell, head of the Catholic Diocese of Los Angeles, invited the Paulist fathers to establish a new parish in the Westwood Hills to serve UCLA and its environs and "the moving picture people." In 1930, property near the north end of the Harold Lloyd Studio Ranch at Ohio and Selby Avenues was purchased, and construction began on St. Paul the Apostle Catholic Community Church. It opened in 1932.

St. Paul the Apostle Church, 1958. Many famous celebrities were associated with St. Paul the Apostle Church. On July 31, 1940, Loretta Young and advertising executive Tom Lewis were married in the new chapel at St. Paul's, with some 3,000 people in attendance.

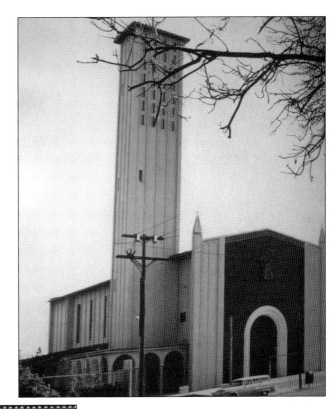

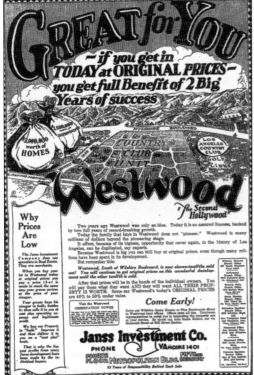

Westwood Hills Country Club Advertisement, 1924. Mentioned in this advertisement was the fact that the Country Club Unit was almost sold out. Located between Wilshire and Santa Monica Boulevards, it was one of the more popular of the Janss units due to its proximity to the Los Angeles Country Club and Beverly Hills. It sold out by June 1925.

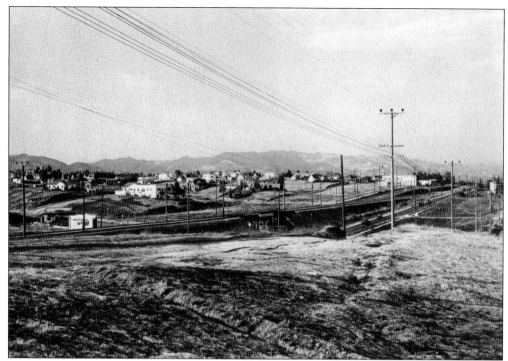

COUNTRY CLUB UNIT, SOUTH, 1929. Looking northeast along Santa Monica Boulevard at Beverly Glen Boulevard (center), with a trestle for the Pacific Electric Railway, the Country Club Unit was located across from the entrance to the Fox Hills Studio backlot on Santa Monica Boulevard.

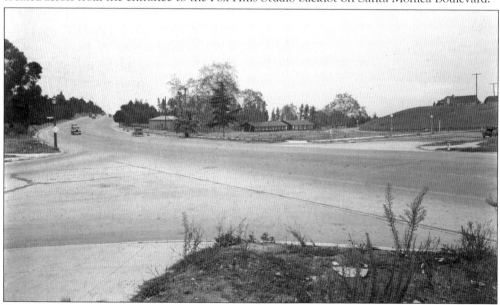

COUNTRY CLUB UNIT, NORTH, 1931. Looking southeast at Wilshire Boulevard and Comstock Avenue, this view shows the Los Angeles Country Club trees on the border of the Country Club Unit. The property on the southeast corner of Wilshire Boulevard and Comstock Avenue was known for many years as the "Pumpkin Patch," where pumpkins and Christmas trees were sold seasonally for decades. Today the 21-story Beverly West condominium towers over the site.

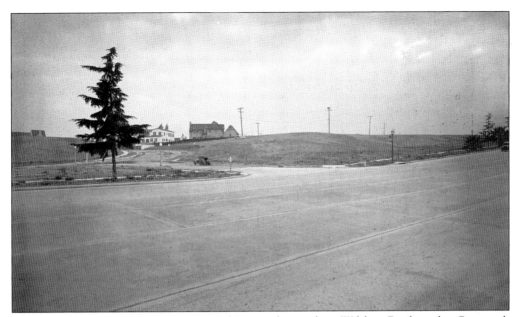

COUNTRY CLUB UNIT, NORTH, 1931. Looking southwest along Wilshire Boulevard at Comstock Avenue, the view here shows that none of the Wilshire Boulevard frontage was developed at this time. By the 1940s, small apartment houses began to line the boulevard.

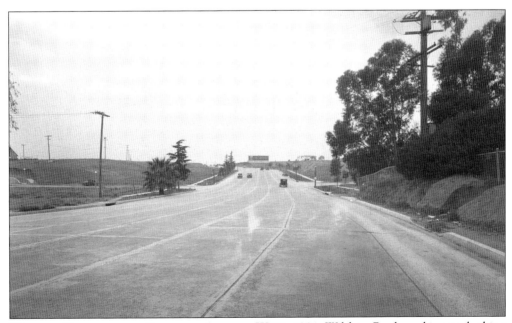

WILSHIRE BOULEVARD AT COMSTOCK AVENUE, WEST, 1931. Wilshire Boulevard is seen looking west, just past the Los Angeles Country Club, with just the Country Club Unit at left and the University Entrance Park Unit at right.

COUNTRY CLUB UNIT, 1928. This aerial view of the Country Club Unit was taken looking north of Santa Monica Boulevard (top), with Ensley Avenue at left and Warnall Avenue at right. The two-story building on the northwest corner of Santa Monica Boulevard at Ensley Avenue was the neighborhood market and general store, now home to Clementine Cafe.

Five

UNIVERSITY ENTRANCE PARK AND HOLMBY HILLS

In 1924, the University Entrance Park Unit was to be predominately a "high-class" residential development for upper-middle-class families. The four-story wooden Westwood Observation Tower was erected by the Janss Corporation in the early 1920s on the northeast corner of Wilshire and Beverly Glen Boulevards, proclaiming the name "WESTWOOD" with incandescent bulbs that could be seen for miles. A Janss tract office was established there for the opening on March 28, 1926.

The lower portion of the Hilgard Avenue area was reserved for multiuse buildings—sororities, charitable organizations, and churches. In 1929, ground was broken for a YWCA at 574 Hilgard Avenue opposite the UCLA campus, and a photograph of Sorority Row appeared in the *Los Angeles Times*. Namesake Eugene Woldemar Hilgard (1833–1916) was a geologist of worldwide stature at the University of California at Berkeley.

St. Alban's Episcopal Church was built in 1931 at 580 Hilgard Avenue to serve UCLA. The original chapel building was designed by Reginald O. Johnson and dedicated in March 1941, and the main church was designed by architect Percy Parke Lewis. The Twenty-eighth Church of Christ Scientist (Christian Science) was constructed in 1928 at 1018 Hilgard Avenue. The site for Warner Avenue Elementary School at 615 Holmby Avenue, bounded by Loring, Woodruff, Warner, and Holmby Avenues, was purchased by Los Angeles City Schools from the Janss Investment Company in 1927. By 1929, the school was being used as a teachers training school in cooperation with UCLA, with new buildings added between 1946 and 1950.

Arthur Letts's vision of a subdivision of only large estates was realized in the Holmby Hills section, named after his estate in Hollywood and his family estate in Holdenby, England. The streets were named after English locales: Devon Avenue, Charing Cross Road, Conway Avenue, Carolwood Drive, and Delfern Drive. Architectural themes included Spanish, English Manor, Tudor, Mediterranean, and American Colonial styles.

Celebrities buying properties in Holmby Hills have included the following: Barbara Stanwyck and Robert Taylor, 423 North Faring Road; Neil Diamond, 161 South Mapleton Drive; Aaron Spelling, 594 South Mapleton Drive; A. H. Giannini (Bank of America), 161 South Mapleton Drive; Irene Dunne, 461 North Faring Road (1936); Bing Crosby, 594 South Mapleton Drive; Jack Benny, 10231 Charing Cross Road; Arthur Letts Jr./Hugh Hefner (Playboy Mansion), 10236 Charing Cross Road; and Jayne Mansfield/Englebert Humperdink (Pink Palace). Carolwood Drive homes included those of Sonny and Cher, Barbra Streisand (301), Frank Sinatra (320), Clark Gable (325), Walt Disney (355), and Gregory Peck (375). MGM star Jean Harlow was one of the early residents (1937) at 1535 Club View Drive.

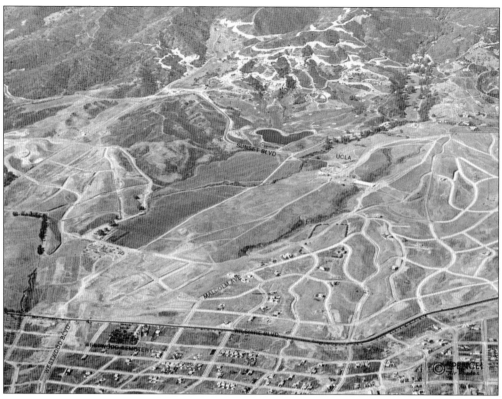

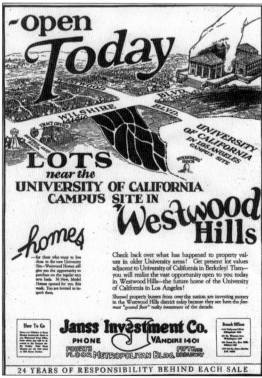

UNIVERSITY ENTRANCE PARK, 1928. UCLA campus construction had begun in 1927, and by 1928, the first campus structure—the Arroyo Bridge—was completed. Thirty homes were built on the hills to the east of Hilgard Avenue. Sunset Boulevard is to the north (Beverly Boulevard), and Wilshire Boulevard is to the south, with Malcolm Avenue already constructed in the center. The roads were dirt and stayed that way for another year or so. Westwood Village roads were being graded at bottom left. The new development of Bel-Air is north of Sunset Boulevard.

WESTWOOD HILLS/UNIVERSITY ENTRANCE PARK ADVERTISEMENT, 1925. This advertisement about "Westwood's Crowning Glory"—the development of the new UCLA campus—warned potential buyers that Westwood property was selling out quickly. Note the drawing of the Westwood Observation Tower (above center, far left).

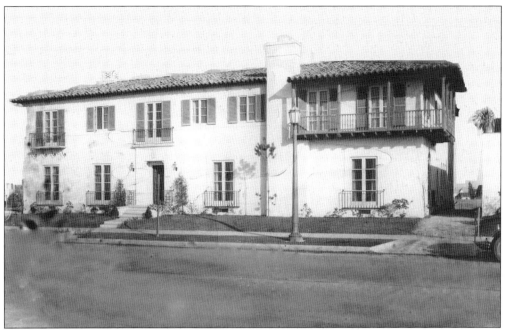

GAMMA PHI BETA SORORITY, 1929. Hilgard Avenue was chosen as Sorority Row, and by 1929 several sorority houses were built, mostly in the Spanish Mediterranean style. Gamma Phi Beta (Alpha Iota Chapter) at 616 Hilgard Avenue was located at the top of Sorority Row.

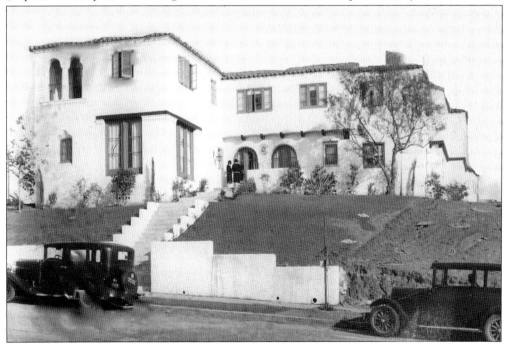

SIGMA KAPPA SORORITY, 1929. From 1928 to 1935, a total of 21 sororities purchased lots on Hilgard Avenue. Sigma Kappa built its house at 726 Hilgard Avenue in the familiar Spanish Colonial Revival style, resembling many of the Janss-designed homes located behind Sorority Row in the University Entrance Park Unit.

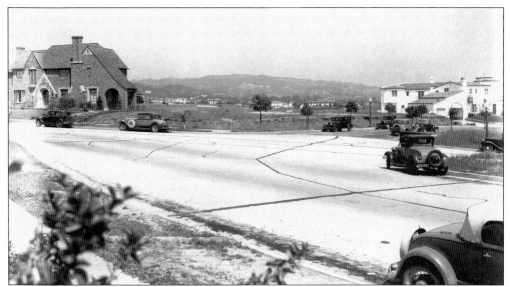

HILGARD AVENUE AT WARNER AVENUE, 1933. The Great Depression left many lots unsold as homes dotted the Westwood countryside, surrounded by open space. By 1940, another sales boom resulted in Westwood Hills development's success despite the difficult economic times.

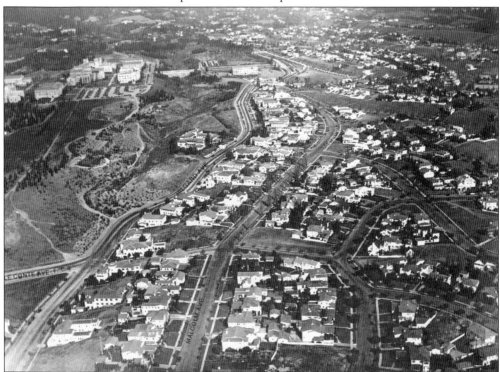

UNIVERSITY ENTRANCE PARK, 1941. This northward view depicts Hilgard Avenue on the west border and Malcolm Avenue in the center. UCLA is seen at left, located on a plateau overlooking the entire area. Since the beginning, the University Entrance Park Unit was one of the higher priced units due to lot sizes, larger homes, and proximity to UCLA. Clearly visible is the Arroyo Bridge west of Hilgard Avenue.

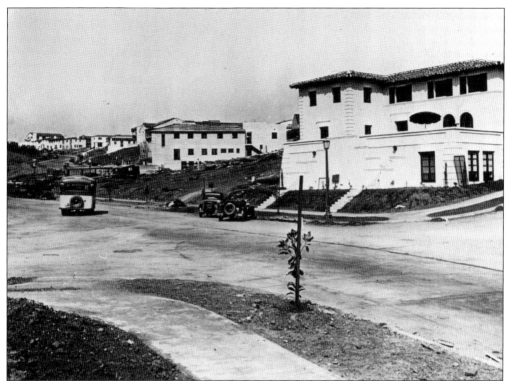

UCLA SORORITY ROW, 1929. The northeast intersection of Hilgard and Le Conte Avenues shows several newly constructed sorority houses, most of which were built into the sloping landscape.

KAPPA KAPPA GAMMA, 1929. Located at 740 Hilgard Avenue, at the northeast corner of Hilgard and Manning Avenues, the UCLA chapter of Kappa Kappa Gamma was one of the first sororities to construct a new chapter house on Westwood's Sorority Row, built in the signature Mediterranean architectural style.

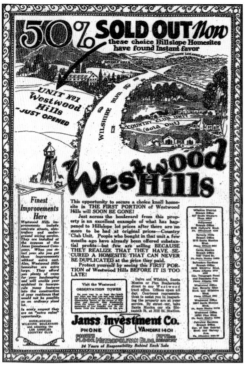

UNIVERSITY PARK UNIT, EAST, 1929. This advertisement announced that the east end of the University Park Unit was 50 percent sold out. Located across Wilshire Boulevard from the Country Club Unit, both units were adjacent to the Los Angeles Country Club, making them highly desirable. Note the Westwood Observation Tower prominently featured at left in the advertisement.

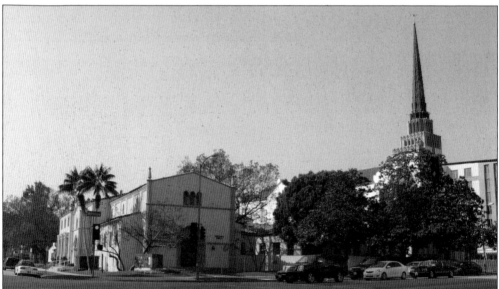

WESTWOOD UNITED METHODIST CHURCH, 2009. Located at 10497 Wilshire Boulevard on the northeast corner of Warner Avenue in the University Park Unit, this property was purchased in 1926. Originally known as the Westwood Community Methodist Church, the site spanned 180 feet of Wilshire frontage. By 1929, funds were raised to build a chapel, later known as Helms Hall. By 1950, architect Harold E. Wagoner began designing a Gothic Moderne–style church building. On July 1, 1951, the new larger church with its tall steeple was dedicated, becoming the most prominent landmark on Wilshire Boulevard, with its tall steeple, long before any high-rises were built.

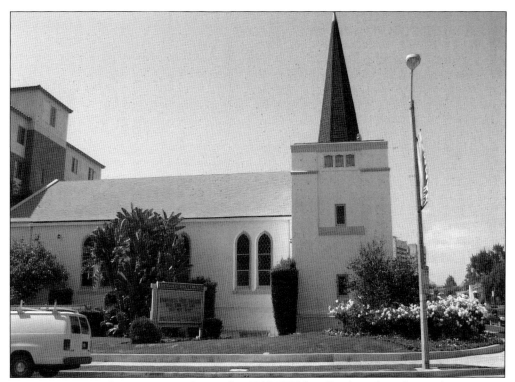

UNIVERSITY BIBLE CHURCH, 2009. Located at 10801 Wilshire Boulevard on the northwest corner of Malcolm Avenue, this house of worship is an evangelical/independent church established in the University Entrance Park Unit in 1937. The congregation began in the late 1930s as a Bible club ministry with UCLA students who met in Westwood Village. The church was designed by H. O. Sexsmith in a simple Gothic Moderne style to accommodate 1,100 parishioners.

UNIVERSITY ENTRANCE PARK, UNIT NO. 4, 1926. This advertisement announced the opening of the last unit of University Entrance Park on the northwest corner of Wilshire and Beverly Glen Boulevards. Janss sales executive A. H. Wilkins and his staff invented the slogan "Wilshire Boulevard, the coming Park Avenue of the West." Wilkins posted a sign with this phrase on the corner in 1934. By 1938, Wilshire Boulevard was well lined with buildings. One of the most prominent of them was the charming Marie Antoinette Apartments at the northeast corner of Wilshire Boulevard and Malcolm Avenue, opposite the University Bible Church.

THE TEN-THOUSAND-FOUR-O-ONE WILSHIRE APARTMENTS, 1951. One of the first two high-rise buildings constructed on Wilshire Boulevard in Westwood was on the northwest corner of Beverly Glen Boulevard. This 150-unit, 11-story apartment building was built on the site of one of the Janss Real Estate offices that sold University Entrance Park property.

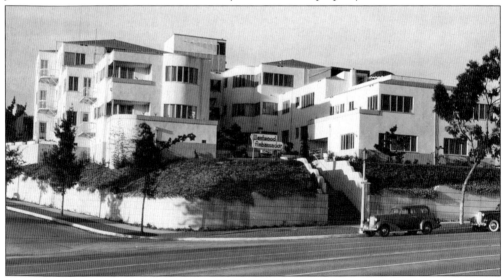

WESTWOOD AMBASSADOR APARTMENTS, 1938. The Westwood Ambassador Apartments opened on February 14, 1937, designed by noted architect Milton J. Black in the Streamline Moderne style. The 19-unit building at 10427 Wilshire Boulevard, on the northeast corner of Holmby Avenue, was one of the corridor's more architecturally significant buildings. Sadly, it was demolished, and all that remains are portions of the entry steps and retaining wall.

WILSHIRE COMSTOCK COOPERATIVE APARTMENTS, 1964. Built on property bought from the estate of entertainer Red Skelton by the Tishman Company, these twin towers are located on the northwest corner of Wilshire Boulevard and Comstock Avenue. The first 21-story "Luxury Cooperative" tower was completed in 1962. A second tower, named Wilshire Comstock East, was built next door and opened in May 1964.

MARIE ANTOINETTE APARTMENTS, 1966. The charming Marie Antoinette Apartments were designed by Percy Parke Lewis in 1936 and completed in August 1938. The French Colonial design was popular in Los Angeles in the 1930s (demolished). Next door, the Marie Antoinette Tower, a 16-story luxury apartment house (now demolished), was designed by Weber and Nicolson and opened in 1963.

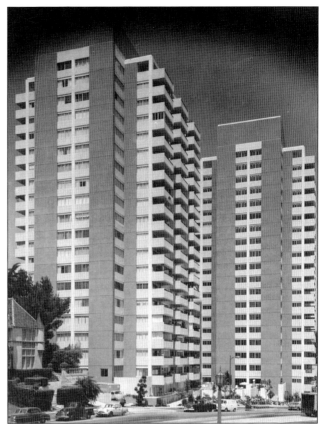

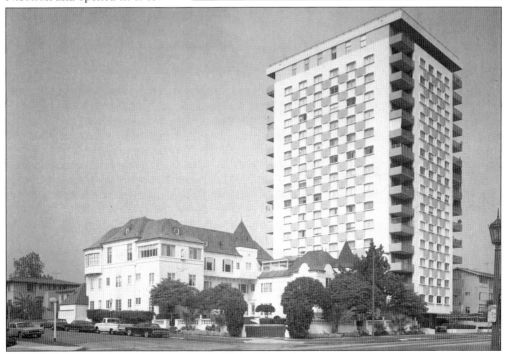

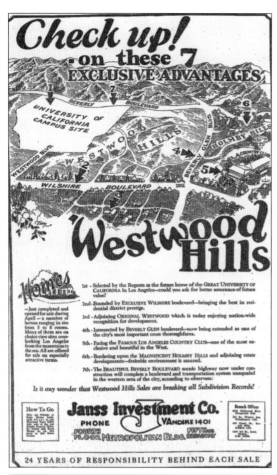

JANSS INVESTMENT COMPANY ADVERTISEMENT, 1926. Janss Company's advertisement and map pointed out seven advantages of buying a homesite in the vicinity of the new planned university campus in its University Entrance Park Unit, just west of its Westwood Hills development.

HOLMBY HILLS ESTATES UNIT, 1928. This northward view of Sunset Boulevard, center, shows Whittier Drive at right and Beverly Glen Boulevard at far left. The Arthur Letts Jr. Estate can be seen at bottom left on Charing Cross Road. The construction of the western link of Beverly Boulevard (later renamed Sunset Boulevard) began in January 1925.

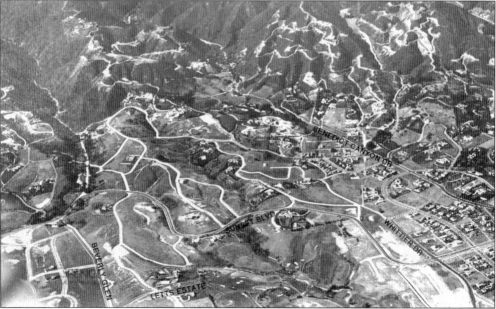

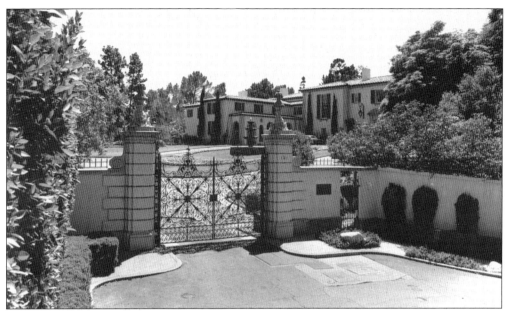

OWLWOOD ESTATE, 1947. In 1932, businessman C. H. Quinn announced his purchase of property in the Holmby Hills Estates Unit and his intentions to build a huge home there. The estate at 141 South Carolwood Drive was named Owlwood and was inhabited in 1934. Architect Robert Farquhar designed the 12,000-square-foot mansion in the Italian Renaissance style. Florence Letts had divorced Arthur Letts, married Charles Quinn, and moved into Owlwood. Notable people who have lived at Owlwood include producer Joseph Schenck, William Keck, Marilyn Monroe as a guest in the 1960s, and Sonny and Cher.

JEAN HARLOW ESTATE, 1934. Located at 214 South Beverly Glen Boulevard, Jean Harlow's Holmby Hills home was a 1.3-acre property in 1932. The "Blonde Bombshell" moved into her stately new white mansion in 1933. By 1935, film producer Nat Levine purchased the estate for $125,000.

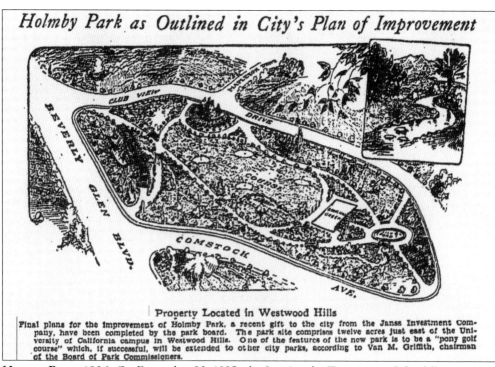

Holmby Park as Outlined in City's Plan of Improvement

Property Located in Westwood Hills

Final plans for the improvement of Holmby Park, a recent gift to the city from the Janss Investment Company, have been completed by the park board. The park site comprises twelve acres just east of the University of California campus in Westwood Hills. One of the features of the new park is to be a "pony golf course" which, if successful, will be extended to other city parks, according to Van M. Griffith, chairman of the Board of Park Commissioners.

HOLMBY PARK, 1926. On December 20, 1925, The *Los Angeles Times* carried the following item: "Janss Firm Gives City Park Area . . . In a joint announcement yesterday (December 19th), Edwin and Harold Janss assured Los Angeles of a new public park in the Wilshire district (Westwood Hills Development). This will be in the form of a gift from the Janss Investment Company and the Holmby Corporation of a tract of land adjacent to the Los Angeles Country Club and extending west to Beverly Glen Boulevard."

HOLMBY PARK, 1927. Bounded by Beverly Glen Boulevard, Club View Drive, and Comstock Avenue, the park contained a wide array of exotic trees, a small 18-hole golf lawn, a pony course, gardens, a bowling green, streams with "water feature" falls, and a fishing pond. The golf course is now named for Armand Hammer, who once lived across the street.

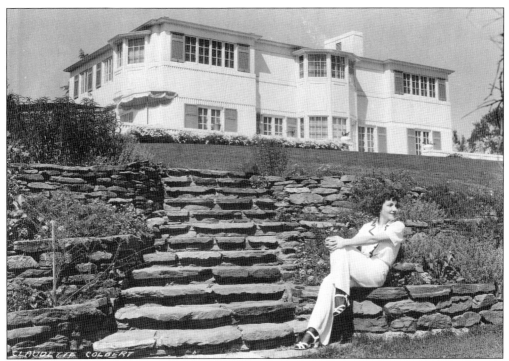

CLAUDETTE COLBERT'S ESTATE, 1941. Located at 615 North Faring Road, Colbert's Holmby Hills home was designed in 1935 by architect Lloyd Wright in Hollywood Baroque style as a "White Mansion" on a hill in 1935. It was the second home on the block. Colbert lived there with her husband, Dr. Joel Pressman, a surgeon at UCLA Medical Center.

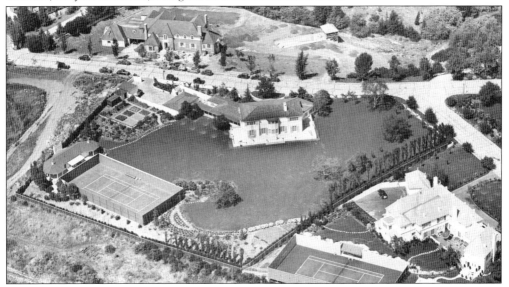

NORTH FARING ROAD, 1937. Looking northeast at Faring Road and Parkwood Drive in Holmby Hills, the Claudette Colbert Estate is in the center at 615 Faring Road. Called the "White Mansion," it is perched on a hill overlooking Beverly Glen Boulevard, where the sun would shine most of the day through the large windows on both floors of her home. The estate had a tennis court and gardens but no swimming pool—unusual for a Hollywood star.

WALT DISNEY ESTATE, 1958. In 1948, Lillian Disney telephoned Harold Janss asking about purchasing a property in Holmby Hills. Janss showed the Disneys a 2.5-acre parcel on a bluff at 355 Carolwood Drive. The 5,669-square-foot, 17-room house was designed in the Contemporary style by architect James Dolena and included a swimming pool and recreation building as well as a half mile of track for Walt's miniature train, the "Carolwood Pacific Railroad." The Disney family lived in Holmby Hills into the 1990s.

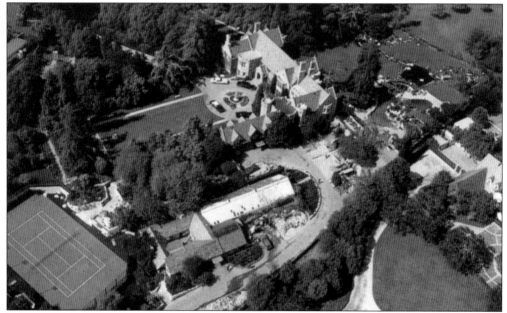

ARTHUR LETTS JR. ESTATE/PLAYBOY MANSION, 2000. This Tudor–style mansion with Gothic elements and grounds at 10236 Charing Cross Road was commissioned by Arthur Letts Jr. in 1927. The 30-room mansion was designed by architect Arthur R. Kelly in the Holmby Hills Estates Unit. The Letts family moved into the estate in 1928. In 1971, the estate was sold to Playboy Enterprises, Inc., and founder Hugh Hefner has transformed it into the Playboy Mansion West for the past four decades.

Six

UCLA

On November 21, 1924, the University of California Board of Regents formed a site committee for expansion. Meetings with the Janss Investment Corporation, as well as an exhaustive consideration of 17 possible sites, led to the March 20, 1925, decision to move the UCLA campus to Westwood. Two hundred acres was first deemed sufficient for the university, but incremental additions put the overall total at 383 acres. The Southern Branch of the University of California became University of California at Los Angeles or UCLA on February 1, 1927.

UCLA flourished during the Depression along with Westwood Village. Various schools were established, and buildings were added in the Romanesque style with landscaping complementing the Italian Mediterranean buildings. The School of Fine Arts began in 1940, the College of Engineering (now the Henry Samueli School of Engineering and Applied Science) established in 1944, and the Cancer Research Institute and the Institute of Industrial Relations opened in 1945. On January 16, 1946, the California Legislature unanimously passed a bill appropriating $7 million for construction of a medical school on the UCLA campus, initiating one of the world's largest and most prestigious medical centers.

The Institute of Geophysics and Planetary Physics was inaugurated as well as the School of Law. By 1949 the UCLA campus included Engineering Units II and III, the Botany Building, the Laboratory of Nuclear Medicine and Radiation Biology, the Marion Davies Children's Clinic, and the Student Union. Existing buildings on the campus included the Nursery Kindergarten Groups Building, and the School of Nursing was founded at this time. On November 4, 1951, the UCLA Law Building was dedicated. In April 1952, the construction of the $20 million UCLA Medical Center was well underway. It opened in 1955.

The regents changed the school's official name to The University of California, Los Angeles in 1958. In 1960, Franklin D. Murphy became chancellor, ushering in a new decade of growth. In February of that year, UCLA's 40th anniversary as a campus of the University of California was marked.

The University Research Library (now the Young Research Library) was completed in 1964. UCLA's 50th anniversary was celebrated on May 23, 1969, by the inauguration of Dr. Charles E. Young as chancellor, which took place in Pauley Pavilion. In 1970, the UCLA campus had 71 departments of instruction, the Research Library, Powell Library, Clark Library, and 15 specialized libraries with 2.75 million catalogued books. There were 1,762 professors and teachers on staff.

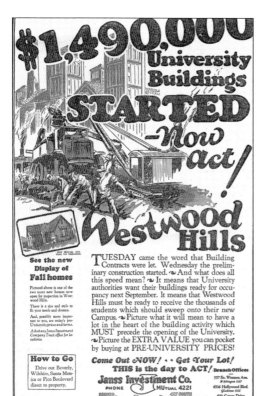

Janss UCLA Advertisement, 1927. A full-page advertisement in the *Los Angeles Express* on February 10, 1927, announced, "$1,490,000 University Buildings STARTED—Now Act! Westwood Hills. Wednesday the preliminary construction started. It means that University authorities want their buildings ready for occupancy next September . . . Come out now! Get your lot." The advertisement showed a rendering of Royce Hall, which would become UCLA's signature building.

UCLA Founder's Rock, 1926. In 1926, this 75-ton solid granite boulder was transported to the UCLA site, where it marked the future dedication spot of the Westwood campus. The *Los Angeles Times* wrote on February 14, 1926, "Campus Dedication, come to the most momentous event in the history of Westwood Hills! Tuesday, February 16, the University of California will formally accept Westwood Hills as the future home of the University of California in Los Angeles. At this event the deeds to the new property will be delivered to the Board of Regents."

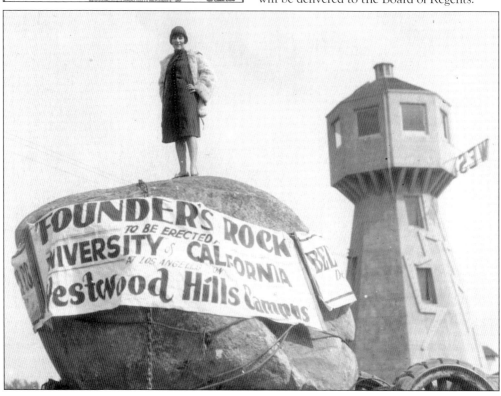

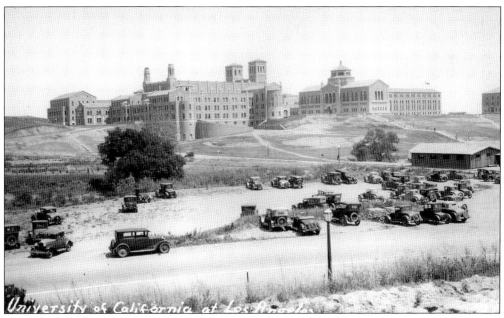

ORIGINAL BUILDINGS, 1929. Ground was broken on September 21, 1927, for the construction of the new university campus. Director Ernest Carroll Moore turned the first shovelful of soil. In the presence of brothers Edwin and Harold Janss among university dignitaries, the first four buildings included Royce Hall, the library, chemistry building (later Kinsey Hall), and now the humanities building.

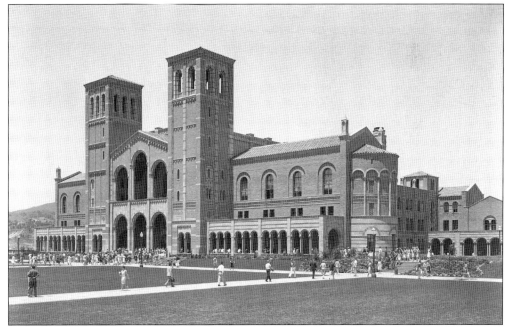

ROYCE HALL, 1930. Royce Hall was designed by architect David Allison in Italian Romanesque style, modeled after the centuries-old Basilica of Sant'Ambrogio in Milan, Italy. The University of California at Los Angeles officially moved to the Westwood site in 1929. Under construction were Haines and Kinsey Halls and the College Library, later named Powell Library.

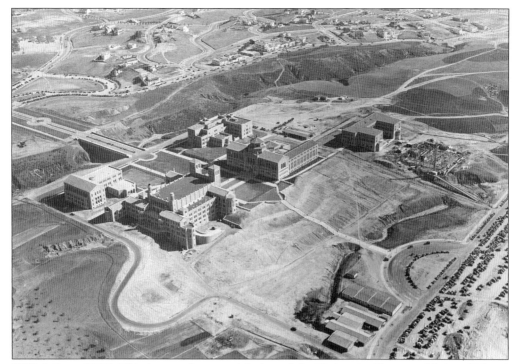

UCLA SITE, 1930. This is a southeast aerial view of the University Entrance Unit at Hilgard Avenue, as seen on February 17, 1930. Visible at far left is the Arroyo Bridge. The first buildings were Royce Hall, College Library, and the chemistry and physics-biology buildings. Kerckhoff Hall is seen under construction at far right next to the education building. On March 27 and 28, 1930, the formal dedication of the University of California at Los Angeles took place. Speakers at the ceremonies included Dr. Arthur Thompson of the University of Aberdeen and Dr. Ernest Carroll Moore, director of UCLA. Delegates representing 168 colleges and universities from around the world were present.

LE CONTE AVENUE GATE, 1932. The Le Conte Avenue Gate area is packed with visitor cars on February 15, 1932, when UCLA marked its history with a talk by Dr. Albert Einstein. He addressed the 2,200 students and faculty members who filled every available inch of space in Royce Hall Auditorium. The handsome Reo brick and stone gate was a gift from brothers Edwin and Harold Janss.

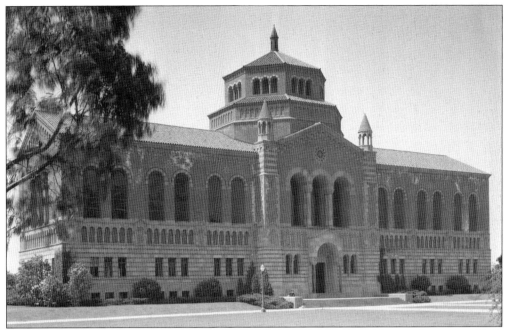

POWELL LIBRARY, 1930. The Library—later named in honor of UCLA librarian Lawrence Clark Powell—is notable for its outstanding decorative beauty in the Italian Renaissance style designed by architect George W. Kelham. At the landings of the stairways stand tall, arched windows of painted glass, symbolizing art, law, science, and sports. Ceilings in the library are deeply coffered with painted woodwork. Seals of colleges the world over and other designs in red tile decorate the foyer of the building.

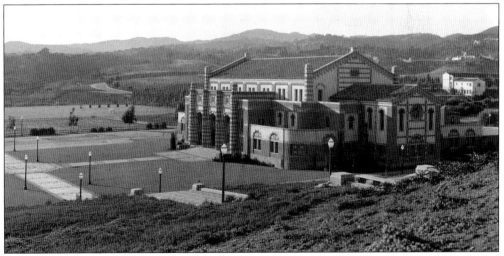

WOMEN'S GYMNASIUM, 1934. With funds from the sale of UCLA's former Vermont Avenue campus, the men's and women's gymnasiums were constructed. To the right at the bottom of Janss Steps is the women's gymnasium. Opened in September 1932, the gymnasium housed a swimming pool, glass-enclosed solarium, and dance and athletic rooms. Designed by architectural firm Allison & Allison in the Italian Romanesque style, the women's gymnasium was remodeled in 2004 and named Gloria Kaufman Hall, home to UCLA's dance program and World Arts and Culture Department.

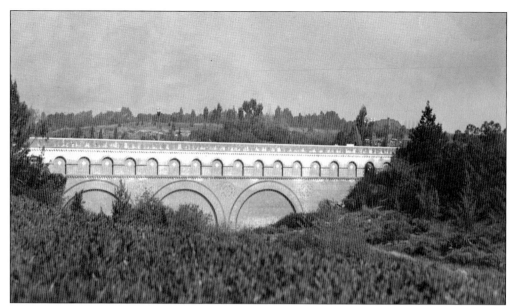

ARROYO BRIDGE, 1938. Built in 1927 as the first structure on the new UCLA campus, this bridge was originally to span a deep ravine that cut through the campus for construction access. It was designed with Romanesque arches that complemented the later Romanesque buildings on campus. In 1947, the ravine was filled in, burying the bridge, to make way for new buildings. The bridge looked like an ancient Roman aqueduct.

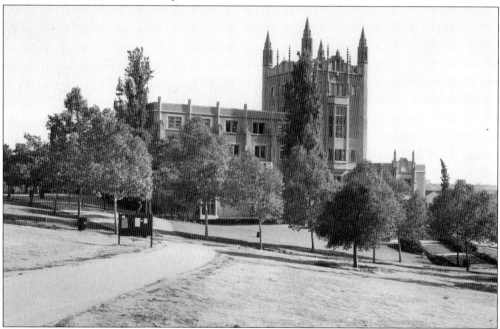

KERCKHOFF HALL, 1937. Dedicated as the original Student Union building on January 20, 1931, the only Tudor Gothic–style building on the UCLA campus was reminiscent of Henry VII's Chapel at Westminster, England. The $715,000 donation for the construction came from Louise E. Kerckhoff to honor her late husband, William G. Kerckhoof, a pioneer financier and electric power developer.

DODD HALL, 1950. Opened in September 1948 as the Business Administration and Economics Building, Dodd Hall was the first major building completed after World War II. Designed in the Italian Renaissance style by architect John C. Austin, the three-story structure housed classrooms, laboratories, a 200-seat lecture hall, a 394-seat auditorium, faculty offices, business administration, visual communications and journalism departments, and the Institute of Industrial Relations.

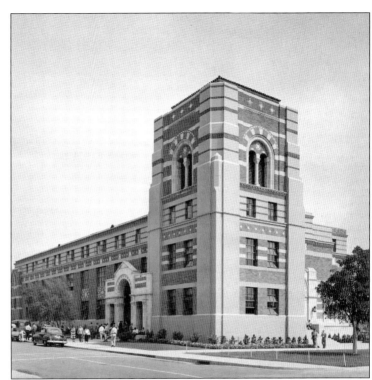

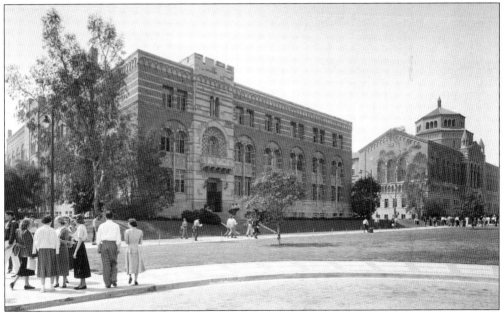

KINSEY HALL, 1950. Opened in May 1929, Kinsey Hall originally was known as the Chemistry–Physics Building and was one of four original buildings that formed the quadrangle. Designed in the Italian Renaissance style, it once housed laboratories and classrooms of the Department of Physics and the College of Agriculture. In the subbasement were rooms especially designed and constructed for the study of acoustics. By the 1990s, Kinsey housed writing programs, women's studies, communications, language, and culture studies. The building was renamed the Humanities Building in 2006.

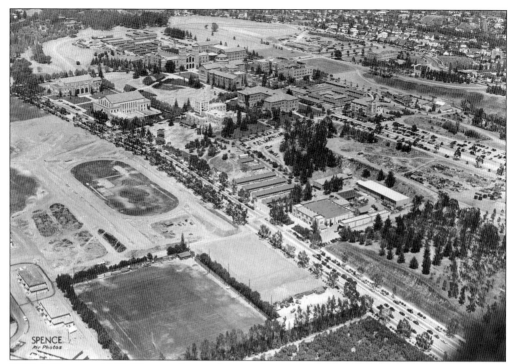

UCLA Campus, 1947. This northeasterly view shows a campus with just 11 major buildings and many temporary bungalows. At left are the athletic fields with the adjacent men's and women's gymnasiums, the track, and the agricultural planting field laboratory below. At center is the Mechanical Arts Building of the College of Engineering. At top center is Royce Hall, Powell Library, and Haines and Kinsey Halls. Other buildings at the top center include Kerckoff Hall, Moore Hall, Franz Hall, and the Administration Building, later renamed Murphy Hall.

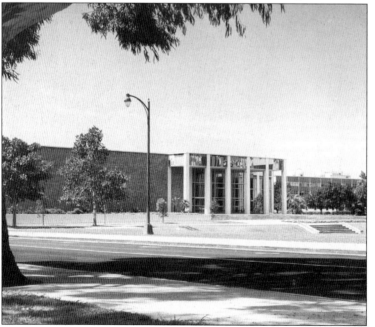

Schoenberg Music Building, 1956. Opened on November 13, 1955, Schoenberg Hall was named after famous composer Arnold Schoenberg, a former member of the UCLA music faculty. The facade is decorated with a mosaic depicting the history of music. The multipurpose facility houses an auditorium, classrooms, offices, music library, various rehearsal rooms, and a recording studio. It is also home to the Bruin Marching Band.

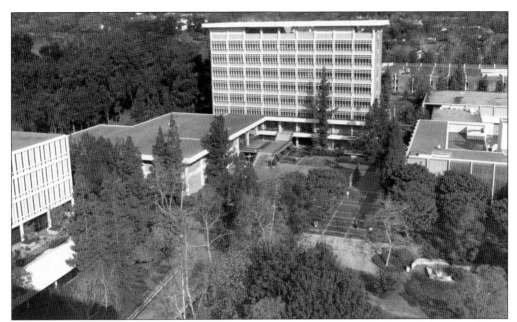

NEW DICKSON ART CENTER, 1967. Replacing the original Dickson Art Center, the new art building on the north campus opened in 1966 with the adjoining Wight Art Gallery, the low-slung building on the left. At the bottom left is the University Research Library, opened in 1964. At top right is Melnitz Hall, containing the James Bridges Theater and Film School, opened in 1967. To the immediate right is Macgowan Hall, the Theater Arts Building, opened in 1963. The Franklin D. Murphy Sculpture Garden is seen in the foreground.

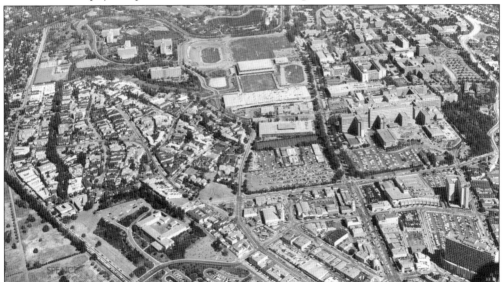

UCLA AND WESTWOOD VILLAGE, 1968. This view looks north over part of Westwood Village, the North Village, and the UCLA campus. The 1950s and 1960s saw significant construction on the UCLA campus. An ambitious project in 1965 was the Edwin W. Pauley Pavilion, which was designed by Welton Becket and opened in June of that year with a 12,829-person capacity. UCLA's 50th anniversary was celebrated on May 23, 1969, by the inauguration of Dr. Charles E. Young as chancellor, which took place in Pauley Pavilion.

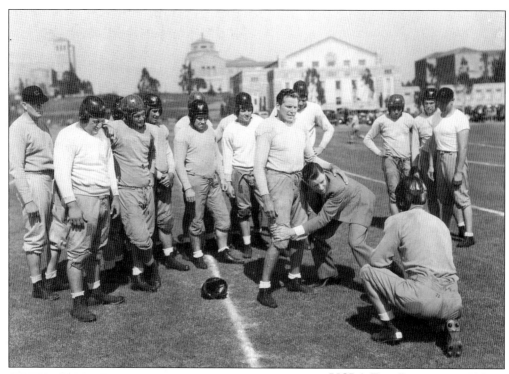

UCLA FILM LOCATION, 1938. The UCLA Athletic Field was used for the 20th Century-Fox production of *Hold That Co-Ed*, starring John Barrymore, George Murphy, and Marjorie Weaver. Directed by veteran director George Marshall, the plot concerned a gubernatorial candidate who aids a needy college by plotting to assure a football team victory.

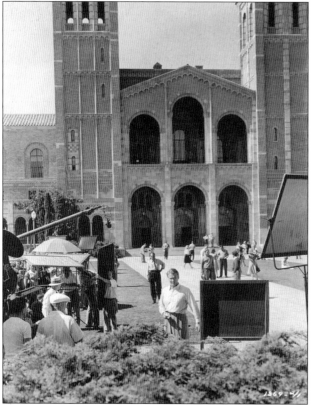

FILMING ON LOCATION, 1940. Paramount's *The Quarterback* was filmed in and around the UCLA campus. Directed by H. Bruce Humberstone, the film starred Wayne Morris, Virginia Dale, Alan Mowbray, and William Frawley in a story of twin brothers: one studying to be a college professor, the other the star football player. Morris played both roles in this comedy about college life. This scene is being filmed in the Royce Hall Quad area.

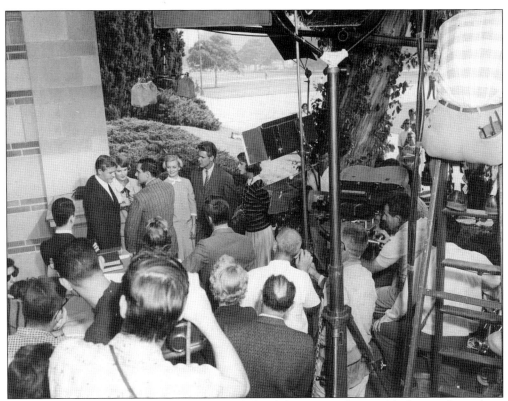

HOLLYWOOD COMES TO UCLA, 1959. This behind-the-scenes photograph depicts the making of the 20th Century-Fox production *Compulsion* (1959), filmed between Royce and Haines Halls. The stars are, from left to right, Dean Stockwell (back of head), Martin Milner, Diane Varsi, and Bradford Dillman. Directed by Richard Fleischer, the film told a fictionalized account of the Leopold-Loeb murder case.

UCLA FILMING, 1964. Peter Fonda starred in *The Young Lovers* for MGM with Sharon Hugueny. Shot on location at UCLA at the top of the Janss Steps, the film shows the west end of Royce Hall in the background. This film followed a college art student who wants a life without responsibilities. He falls in love with a coed but staves off marriage. Soon his lover becomes pregnant, and he must confront the situation.

ROYCE HALL FILM LOCATION, 1958. Columbia Pictures' *Senior Prom* musical starred, from left to right, Jimmie Komack, Jill Corey, Paul Hampton, and Barbara Bostock, shown here posing on the front steps of Royce Hall. The plot follows college students preparing for their prom, wanting Louis Prima and Keely Smith to perform for the graduating class.

Seven
WESTWOOD VILLAGE
1925–1939
NORTH VILLAGE, UNIVERSITY CREST, STREETS OF OLD MONTEREY

Harlan Bartholmew, St. Louis city planner, carefully plotted out the street grid and master plan for the business community in 1927. By February, the Janss Company created a separate construction and development arm, known as the Westwood Mortgage and Investment Company. In 1929, the Janss Company oversaw 26 construction projects, including four sororities, an apartment house, four duplexes, and 17 single-family residences. The district's most distinctive feature, its soaring towers, attracted Wilshire Boulevard traffic. The Holmby and Sears buildings and Fox Westwood Village Theatre were prominent. Four gas stations along Lindbrook Drive were located near the south entrance to Westwood Village. By 1940, Janss was advertising Westwood Village as "America's most unusual shopping center."

Westwood Village's unifying architectural theme was Mediterranean, complementing the Italian and Romanesque architecture at UCLA. The first store open for business was Campbell's Book Store at 10918 Le Conte Avenue. Structures completed in 1929 included the El Encanto Building. The El Paseo Building opened in 1932. It was named for, and patterned after, the El Paseo Building in Santa Barbara and was located on the corner of Broxton and Weyburn Avenues, opposite the Fox Westwood Village Theatre.

Adjacent to the new development, the University Crest Unit was placed on the market in October 1929, as well as the following units: Faculty Unit, planned in 1927; the Country Unit on Thurston Avenue, north of Sunset Boulevard, opened in 1938; Glenroy Knolls along Glenroy and Ashdale Avenues, north of Sunset Boulevard; and the Estate Unit at Groverton Place, north of Sunset Boulevard.

In 1930, the "Streets of Old Monterey" was a new development unit of Westwood Hills to the northwest of Westwood Village, extending to Sunset Boulevard, where "artistic values were to be emphasized." Pools and fountains were transplanted from Andalusia, Spain, and outdoor fireplaces from Mexico. Lovely gates and wishing wells were incorporated into the new development.

Ground was broken in 1930 in the North Village for a two-story, Spanish Mediterranean hotel structure. Later used as a fraternity house at Gayley Avenue and Strathmore Drive, this 35-room structure became a neighborhood landmark. The Strathmore Apartments, designed by famed architect Richard J. Neutra, were built in 1937 at 11009 Strathmore Drive and were designated Los Angeles Historic-Cultural Monument No. 351 in 1988. Well-known residents of the complex included Orson Welles, Luise Rainer, and Charles and Ray Eames.

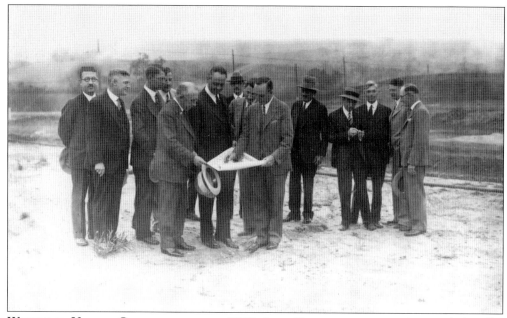

WESTWOOD VILLAGE GROUND-BREAKING, 1928. Janss Company representatives, including Dr. Edwin Janss (second from left), are seen at the Westwood Village ground-breaking on May 30, 1928. Earlier that year, the Village map was drawn, and the grading started in 1929.

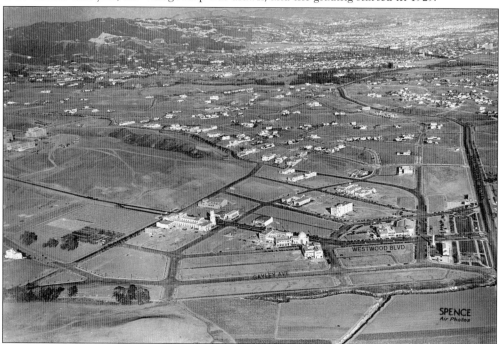

WESTWOOD VILLAGE, 1929. This eastward view shows at top the University Entrance Park Unit, Wilshire Boulevard at far right, and Gayley Avenue in the foreground. The commercial area would contain a unique blend of pedestrian- and automobile-oriented development. Wide sidewalks and landscaping were priorities. Corner buildings would be accessible from both streets and interior courtyards. Visible in the center is the Holmby clock tower on Westwood Boulevard.

MONTANA AVENUE AT VETERAN AVENUE, 1931. This view north to Sunset Boulevard (formerly Beverly Boulevard) shows the area northwest of the UCLA campus that formed the boundary of the North Village and Westwood Hills. North Village boundaries were defined by Gayley Avenue, Veteran Avenue, Le Conte Avenue, Strathmore Drive, and the Veterans Cemetery.

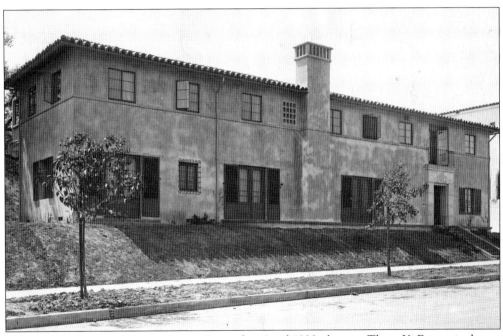

THETA XI FRATERNITY HOUSE, 1930. Opened in April 1930, the new Theta Xi Fraternity house is located at 629 Gayley Avenue, facing the UCLA campus. The architectural firm of Witmer and Watson designed this Italian Renaissance–style building to accommodate 24 male students. The building had 24 rooms. On the main floor were a living room, dining room, library, card and trophy room, office, kitchen, breakfast room, storage, and servants rooms. The second floor had 12 bedroom/study rooms with outdoor sleeping porches for summer.

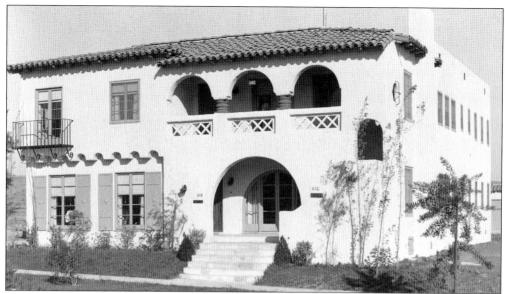

PI THETA PHI HOUSE, 1929. Located at 508 Veteran Avenue in the North Village, this fraternity originated in Des Moines, Iowa, in 1926 and incorporated in 1928. The local chapter subsequently became a chapter of Lambda Chi Alpha national fraternity and later built a house at 10918 Strathmore Drive.

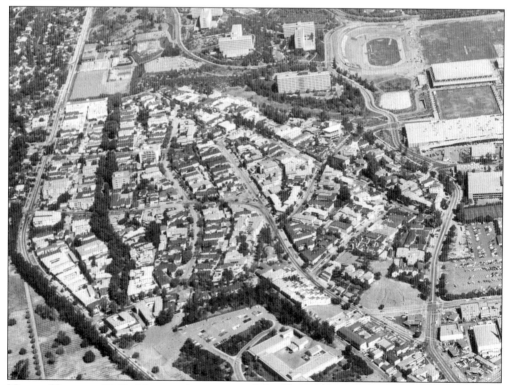

NORTH VILLAGE, 1968. Veteran Avenue is at left, Glenrock Avenue is at center, and Gayley Avenue is at far right. This area was designated primarily for student and fraternity housing and included Fraternity Row, several co-ops, and many apartments.

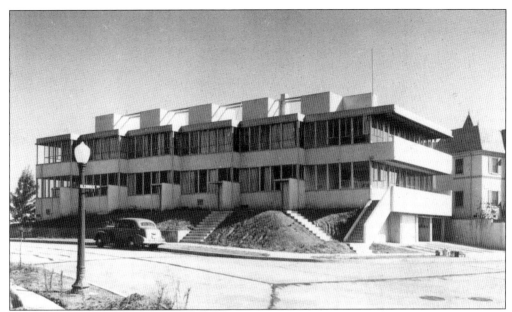

LANDFAIR APARTMENTS, 1938. In September 1937, the Landfair Apartments opened at 10940–10954 Ophir Drive. Designed by architect Richard J. Neutra in the International style, the building was later known as Robison Hall, operated by the University Cooperative Housing Association. It was declared City of Los Angeles Historic-Cultural Monument No. 320 in 1987.

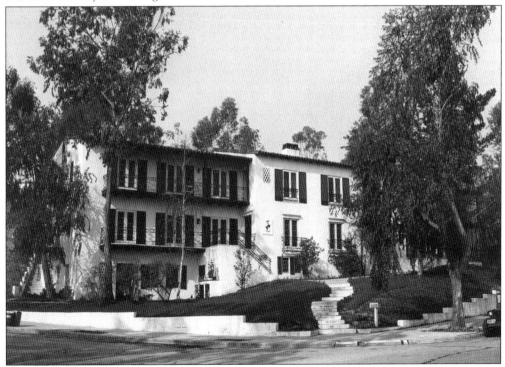

BETA THETA PI HOUSE, 1965. This fraternity house is located at 581 Gayley Avenue in the North Village. Built in 1930 at a cost of $26,000, it was designed by Janss architect Howard Wells in the Spanish Colonial Revival style, as a hotel at the corner of Strathmore Drive.

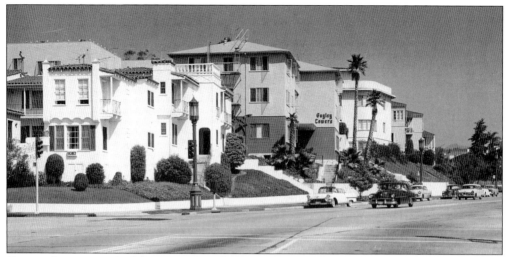

GAYLEY AVENUE, 1959. This view of Gayley Avenue at Weyburn Avenue looks northward. The Gayley Terrace and Gayley Towers Apartments are still popular housing adjacent to Westwood Village and UCLA. Gayley Terrace at 959 Gayley Avenue opened in 1940 and became City of Los Angeles Historic-Cultural Monument No. 363 in 1988, due to its wonderful Spanish Colonial Revival design. It was featured in the remake of *The Nutty Professor* starring Eddie Murphy.

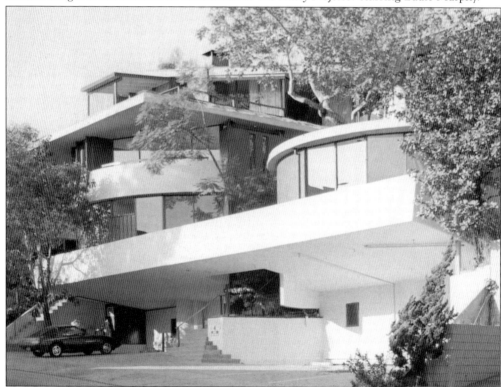

SHEATS ("L'HORIZON") APARTMENTS. In 1949, the *Buck Rogers*–inspired apartments at 10919 Strathmore Drive were completed amid UCLA's Fraternity Row. The eight-unit complex was designed by noted architect John Lautner for UCLA professor Paul Sheats. This landmark became City of Los Angeles Historic-Cultural Monument No. 367 in 1988.

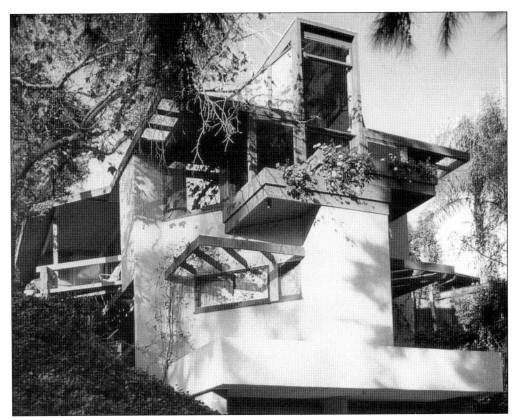

TISCHLER RESIDENCE. Built in 1950 and designed by architect Rudolph Schindler in the International style, this home utilized geometrical elements in its street facade and windows. Located at 175 Greenfield Avenue, the unusually styled residence became City of Los Angeles Historic-Cultural Monument No. 506 in 1990.

UNIVERSITY CREST WESTWOOD UNIT, 1941. Film star Rita Hayworth lived at 201 Veteran Avenue with her first husband, Edward Charles Judson. Hayworth was loaned out to Warner Brothers in 1941 to star in *Strawberry Blonde* and to 20th Century-Fox to appear with Tyrone Power in *Blood and Sand*. Back at her home studio, Columbia, she starred in *You'll Never Get Rich*—all while living in Westwood.

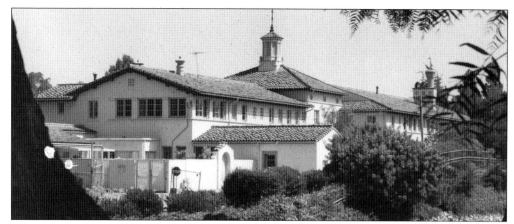

MARYMOUNT UNIT, 1968. Located at 10643 Sunset Boulevard, Marymount High School was developed by the Janss Company. The Religious of the Sacred Heart of Mary, a branch of Marymount in New York, purchased a 7.5-acre site fronting Sunset Boulevard, immediately north of the UCLA campus. Architect Ross G. Montgomery designed the school in the Spanish Colonial Revival style. The campus included the main administration building, classrooms, an auditorium, a chapel, dormitories, and a gymnasium. The school opened on September 23, 1931. Marymount High School was declared Los Angeles City Historic-Cultural Monument No. 254 on September 28, 1982.

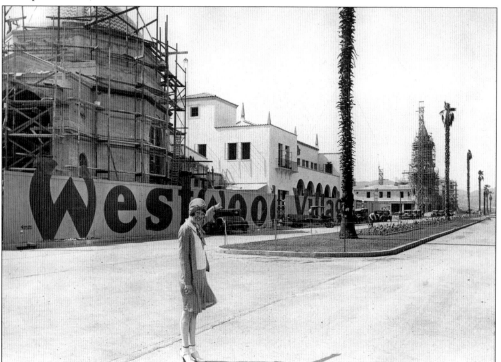

WESTWOOD VILLAGE CONSTRUCTION, 1929. Janss Company representative Rowe Rader points to construction of the Janss Dome and the Westwood clock tower. The Holmby Building, with its clock tower, was designed in the Mediterranean style with English-Norman elements on the clock tower by architect Gordon B. Kaufmann. These are the first of the Janss buildings that would cover the entire block on Westwood Boulevard between Le Conte and Weyburn Avenues.

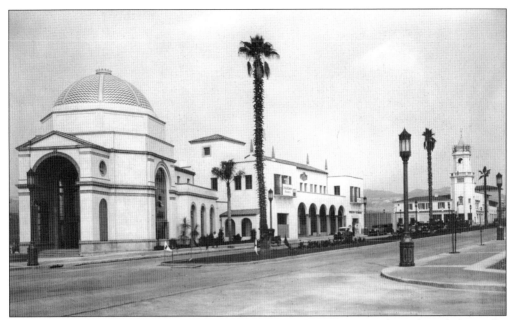

JANSS DOME BUILDING, 1929. This view looking north on Westwood Boulevard shows the completed Janss Dome building and Holmby Building. Covering the dome was blue and gold tile set in a zigzag pattern.

JANSS ADVERTISEMENT, 1929. In March 1929, the Westwood Village Unit opened for the sale of business and income lots. The business district streets included Wilshire and Westwood Boulevards, Lindbrook Drive, and Tiverton, Glendon, Weyburn, Le Conte Kinross, and Gayley Avenues. The Janss Investment Corporation announced that the Village Unit would be "one of the most unusual business districts in the United States." The Westwood Village was a success despite the Depression, which hit just one month after the Village opened in 1929.

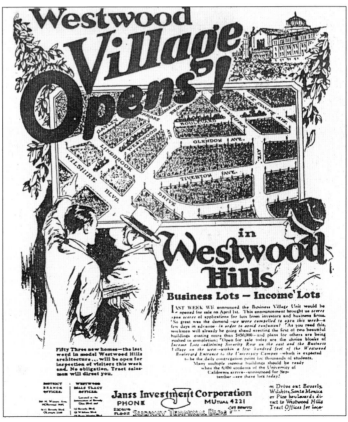

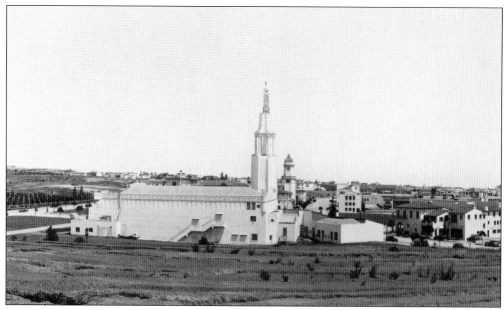

WESTWOOD VILLAGE, 1931. This view looks east at the new Westwood Village Unit, showing the new Fox Westwood Village Theatre at Broxton and Weyburn Avenues. Designed by Percy Parke Lewis, the soaring white tower of the Fox Theatre was the tallest in the Village. The Holmby clock tower is seen in the distance.

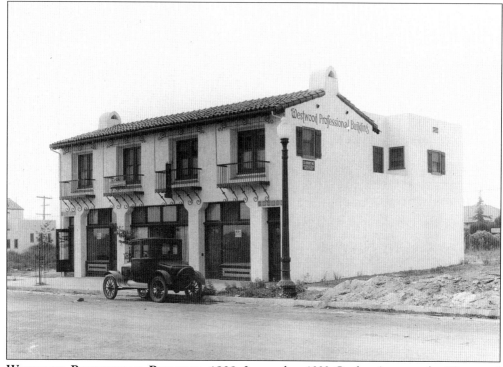

WESTWOOD PROFESSIONAL BUILDING, 1929. Located at 1033 Gayley Avenue, the Westwood Professional Building originally contained the offices of C. A. Lindquist, M.D. (physician and surgeon) and H. M. Hales, D.D.S.

UNIVERSITY PROFESSIONAL BUILDING, 1930. Constructed in 1929 at 1093 Broxton Avenue on the northwest corner, this building was designed in the Spanish Colonial style. The first tenant was Crawford Drugstore, which opened on October 20, 1929. The second was Hamner & Son Collegemen's Shop, which relocated to the Village from Vermont Avenue along with UCLA. Jack Hamner, a UCLA alumnus, sold fashionable men's clothing to the student body.

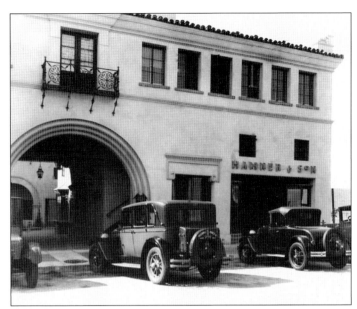

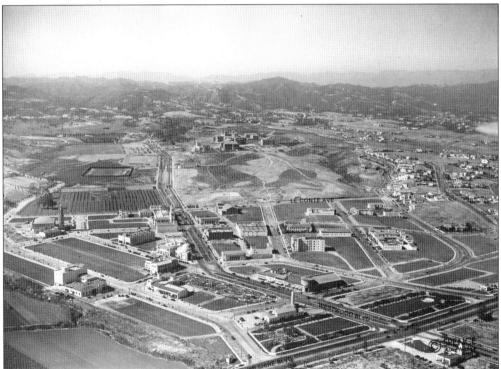

WESTWOOD VILLAGE, 1931. Westwood Village is seen looking north from Wilshire Boulevard in the foreground and Westwood Boulevard at center to UCLA on the hill. Westwood Village businesses included the following: Campbell's Book Store at 10918 Le Conte Avenue, The Huddle Cafe at 938 Westwood Boulevard, and Security-First National Bank of Los Angeles. On March 4, 1930, Desmond's Department Store opened. The Citizen's National Trust and Savings Bank was built on the northeast corner of Kinross Avenue and Westwood Boulevard. Westwood Village marked its first anniversary with a "birthday carnival" on April 11–12, 1930.

UNION 76 GAS STATION, 1931. The grand opening of the new Union 76 Station on the southeast corner of Westwood Boulevard and Lindbrook Drive occurred in December 1931 as part of a massive industry opening of 750 stations citywide. The signature architectural detail was the tower topped with the rotating "76" neon sign that could be seen for miles. The gas station was designed in the Spanish California Mission style with tiled roofs, but was removed in 1936. Sontag Fountain and Grill was built on the site.

POTTER HARDWARE COMPANY, 1930. Originally located at 1020–1022 Westwood Boulevard, Potter Hardware opened in March 1930 in a beautiful Spanish Colonial Revival–style building designed by Percy Parke Lewis. Potter Hardware supplied Westwood and UCLA for many years. It moved to larger quarters at 10935 Weyburn Avenue in 1938 and stayed in Westwood Village for three decades.

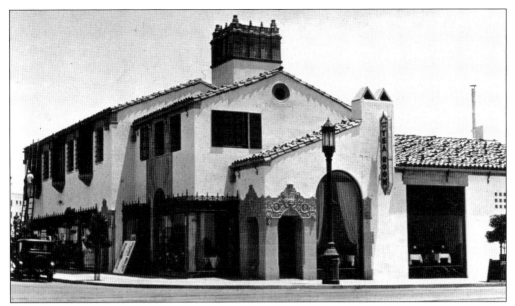

SHEPARD MITCHELL BUILDING, 1930. Opened in July 1930 on the southeast corner of Gayley and Kinross Avenues, this building was designed by Stiles O. Clements in the Spanish Colonial Revival style with churrigueresque ornamentation and a decorative tower. This combination "studio-shop" building housed La Casa Azteca Mexican Art Novelties, Hester's Own Make Ice Cream, Karling Furniture, and Southern Palms Tea Room.

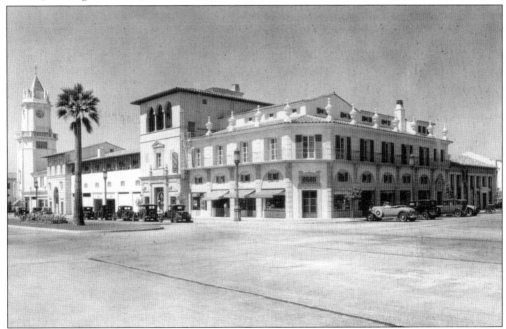

WESTWOOD HOLMBY BUILDING, 1930. Designed by architect Gordon Kaufmann, this single block-long structure was intended to look like one separate building. The second floor, called Holmby Hall, was the first women's dormitory for UCLA's female students. Looking southwest, the Holmby clock tower is at far right. A few of the first tenants included the Sawyer School of Commerce (second floor) and Albert Sheetz Mission Candy Company (1931).

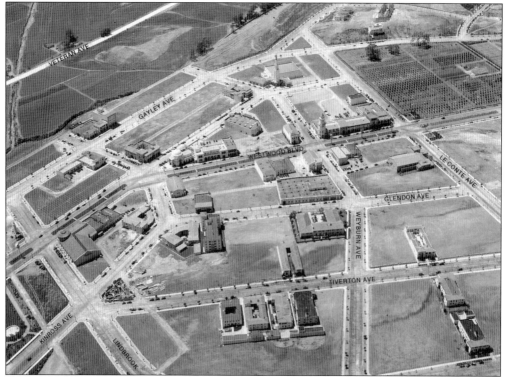

WESTWOOD VILLAGE, 1932. Looking northwest to Gayley Avenue, this view shows the Fox Westwood Village Theatre at top center, Tiverton Avenue at the bottom, Kinross Avenue at left, Weyburn Avenue at center, and Le Conte Avenue at right. Buildings under construction or opening in 1931 included the J. J. Newberry Building. Notice at top right the agricultural land on the UCLA campus that would become the UCLA Citrus Experiment Station.

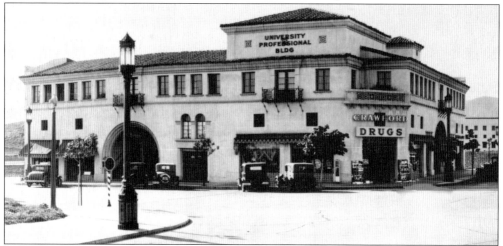

UNIVERSITY PROFESSIONAL BUILDING, 1932. Located at 1093 Broxton Avenue on the northwest corner of Broxton and Kinross Avenues, this two-story, Spanish Colonial Revival store and office building featured large arched entryways on both the Broxton Avenue and Kinross Avenue facades. These arches led into a beautiful inner patio courtyard decorated with glazed ceramic tiles and wrought-iron window details.

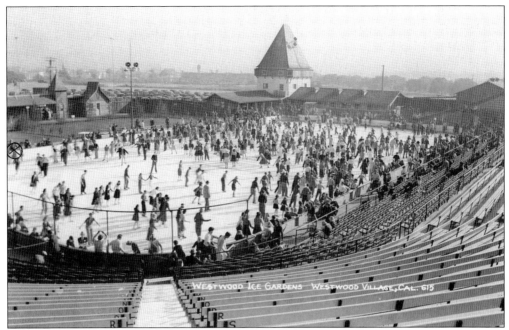

TROPICAL ICE GARDENS, 1938. On November 28, 1938, the Tropical Ice Gardens opened at the southwest corner of Gayley and Weyburn Avenues with the premiere of *St. Moritz Express*, a spectacular ice show. In 1941, *Westwood Ice Frolics* was a 25-act musical revue. A Swiss-style chalet and bleachers seating 10,000 with an open rink was the world's only outdoor all-year ice rink. Olympic gold medalist Sonja Henie skated there in the 1944 film *It's for Pleasure*, and from then on the rink was known as the "Sonja Henie Ice Rink."

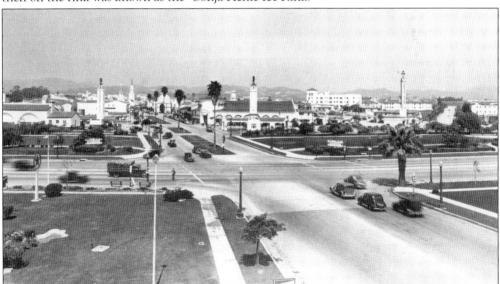

WESTWOOD VILLAGE, 1939. Looking north across Wilshire Boulevard on Westwood Boulevard, Westwood Village indeed shows the characteristics of a small and unique college town. The architectural towers caught motorists' attention along Wilshire Boulevard. The towers are, from left to right, Chevron-Standard Oil, Sears and Roebuck, Fox Westwood Village Theatre, Holmby clock tower, Union 76, and the Associated Oil Flying "A."

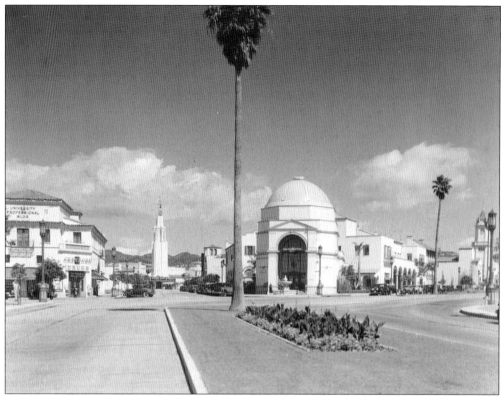

WESTWOOD VILLAGE, 1934. Looking north on Westwood Boulevard to Broxton and Kinross Avenues, this view shows the University Professional Building at left with Crawford Drugstore on the corner, the Fox Westwood Village Theatre at Broxton and Weyburn Avenues, the Janss Investment Corporation's signature dome building, and the Holmby Building complex showing the clock tower at far right. In 1938, the Bank of America relocated in its Westwood branch in the former Janss Dome building.

DESMOND'S WESTWOOD, 1930. Located at the southwest corner of Westwood Boulevard and Weyburn Avenue, Desmond's opened its beautiful Spanish Colonial Revival building on March 14, 1930. Designed by architects John and Donald Parkinson, the building had two floors, plus a basement.

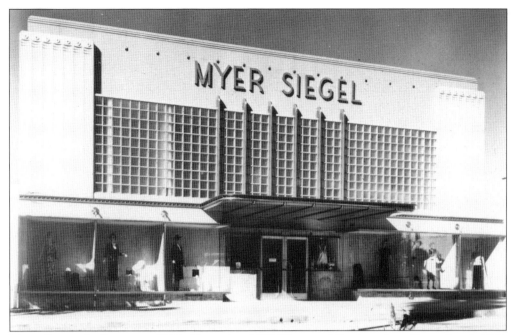

MYER SIEGEL & COMPANY, 1937. Opened at 1025 Westwood Boulevard on December 1, 1937, Myer Siegel store advertised itself as a "Women's Specialty Store." The new building was the most progressive in Westwood Village with its Moderne Mediterranean style designed by architect Allen G. Siple. The features included a large glass-brick panel above the marquee, high ceilings, and beautiful mahogany and stainless steel interiors. Since remodeled, it houses architects BMA Associates.

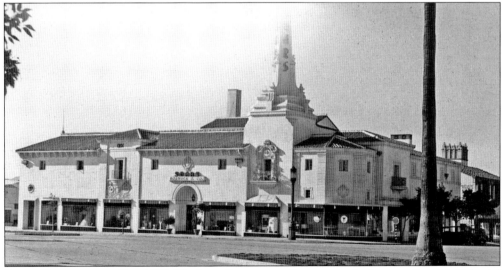

SEARS, ROEBUCK AND CO., 1937. The Janss Investment Corporation built a new Spanish Colonial Revival–style building for Sears, Roebuck and Co. at 1101 Westwood Boulevard on the southwest corner at Kinross Avenue. It opened on July 9, 1936. Designed by Percy Parke Lewis, who also designed the Fox Westwood Village Theatre, the Sears Building featured a signature soaring tower. In February 1939, the building was remodeled and enlarged and, in 1950, was remodeled again, with its reopening on April 27, 1950.

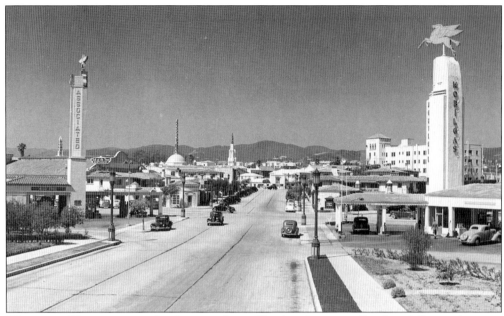

WESTWOOD VILLAGE, 1938. Looking north on Glendon Avenue to Lindbrook Drive, this view shows several of the famous Westwood towers. At left is the Associated Oil Company Flying A gas station, which opened in December 1935. In the background at left is the Bank of America tower on top of the former Janss Investment Corporation Dome building. The bank took over the building in summer 1938. In the far center is the Fox Westwood Village Theatre tower, and at right is Mobil gas station on Lindbrook Drive and Glendon Avenue. To the right is the Mobil gas station with its flying Pegasus.

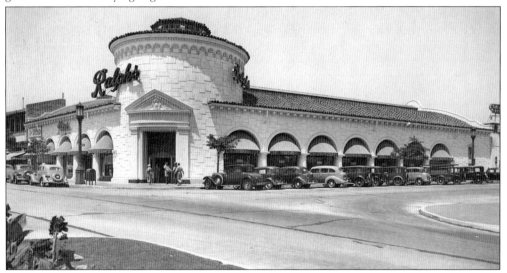

RALPH'S GROCERY, 1939. On November 15, 1929, the *Westwood Hills News* proclaimed, "Planning one of the most auspicious occasions ever witnessed in this community, Ralph's Grocery Market was formally introduced in the construction of a $100,000 building in the Village." Located at 1142–1154 Westwood Boulevard on the northeast corner of Lindbrook Drive, Ralph's opened on November 21, 1929. The building was designed by architect Russell Collins in the Mission Revival style and was declared Los Angeles City Historic-Cultural Monument No. 360 in 1988..

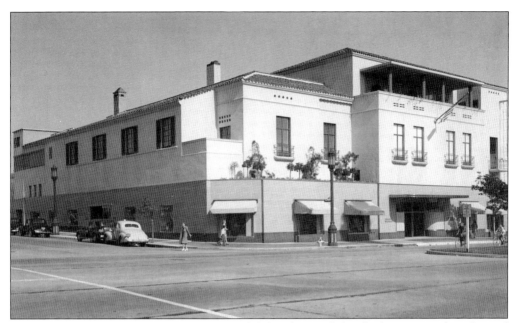

BULLOCK'S WESTWOOD, 1939. The newly remodeled and expanded Bullock's Westwood was located at 1002 Westwood Boulevard. The original 1932 building and its two-story portion at left were enlarged several times. The 1932 and 1939 enlargements were designed by architects John and Donald Parkinson. A tearoom was built on the third floor with an outdoor dining terrace.

WEYBURN AVENUE AT WESTWOOD BOULEVARD, 1939. Looking west to the Fox Westwood Village Theatre at Broxton Avenue, this view shows the Holmby Building clock tower on the northwest corner of Westwood Boulevard at Wetyburn Avenue. Janss Drugstore, managed by Marlowe C. Janss, was located on the ground floor beneath the clock tower at 951 Westwood Boulevard. Later the drugstore was replaced by the Westwood Drugstore, which remained until the early 1980s.

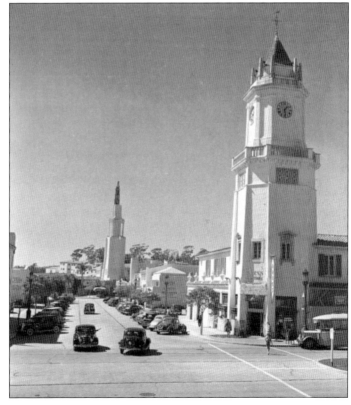

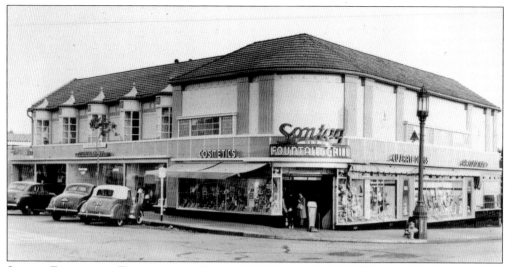

SONTAG DRUGSTORE, FOUNTAIN AND GRILL, 1939. Located at 1160 Westwood Boulevard on the southeast corner of Westwood Boulevard and Lindbrook Drive, Sontag held its ground-breaking on November 7, 1937, and the Colonial-style building opened in 1938. Designed by architect Gordon B. Kaufmann and built by contractor S. N. Benjamin Co. as a multipurpose building, two additional stores were located on Lindbrook Drive. One was occupied by the Stromberg Carlson Radio shop in the 1940s. By 1948, Sontag became a Thrifty drugstore. Today the site is occupied by the Hammer Museum.

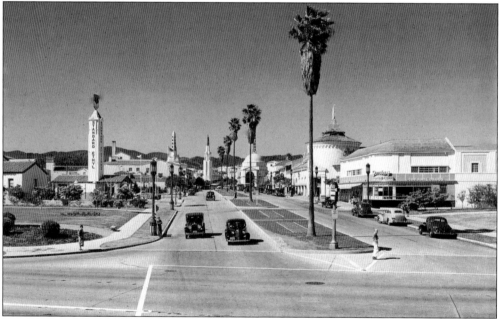

WESTWOOD BOULEVARD AT WILSHIRE BOULEVARD, 1939. Looking north on Westwood Boulevard from Wilshire Boulevard, this vantage point shows, from left to right, the towers of the Standard Station on Lindbrook Avenue, Sears, Roebuck and Co. at Westwood Boulevard and Kinross Avenue, Fox Westwood Village Theatre at Broxton and Weyburn Avenues, the Bank of America at Broxton and Kinross Avenues, Ralph's Market at Lindbrook Drive and Westwood Boulevard, and Sontag Fountain and Grill across the street.

Eight
WESTWOOD VILLAGE
1940–1959

Historian Fred E. Basten grew up in the post–World War II era on Ashton Avenue, two blocks south of Westwood Village. "There were no towering buildings along Wilshire Boulevard in those days," Basten remembered. "The Marie Antoinette Apartments to the west was the tallest structure in sight. After enrolling in Emerson Junior High School, I began to discover the sights in my new neighborhood. A block away, on the corner of Wilshire and Manning, lived Hollywood actress Ann Sothern. Across the driveway from my bedroom window was the front door of a pretty young starlet named Peggy Knudson, and in the front apartment of our building was famed Hollywood director Edmund Goulding who had directed Greta Garbo, Joan Crawford, and Bette Davis. In the Village just west of the Fox Westwood Village Theatre was the Ice Palace and nearby the theaters were hosting some Hollywood premieres that made the Village the place to be and to be seen. I was there too with my autograph book."

Basten continued, "One of the most memorable sneak previews at the Fox Westwood Village Theatre in February of 1948 was for the Fred Astaire/Judy Garland film *Easter Parade*. My favorite music store was Kelly's Music Co. at 1043 Westwood Boulevard (now Tanino Ristorante). Like Wallich's Music City in Hollywood, Kelly's had listening booths. In those days, Westwood Boulevard ran through the Village and UCLA, straight to Sunset Boulevard. At the intersection of Wilshire and Westwood Boulevards was Truman's Drive Inn Restaurant and at the entrance to the Village, on the northern corners, were two large parking lots. Westwood had such a small-town, collegiate feeling. It truly was a village where you could find anything you needed within walking distance. I'd get my hair cut at Oakley's Barber Shop, browse Campbell's Book Store next door, then wander through Phelp's Wilger and Brussell's Men's stores, Desmond's and the old and new Bullock's locations. My first job after graduation from UCLA was in the Promotions Department at the then-new Bullock's. Our family would eat at either the Village Delicatessen, Ships, Wil Wright's Ice Cream Parlor, Mario's Italian Restaurant across from the Fox Westwood Village Theatre, and the English Tea Room. Most of the places from my early memories are gone now, replaced with new structures . . . It was a wonderful place to be as I was growing up, and it's still wonderful as a stroll through today's Village stirs so many fond memories for me."

Westwood Village during these two decades welcomed many new businesses, including Crescent Jewelers (later named Sarah Leonard Fine Jewelers) and Bel-Air Camera & HiFi, joining such Village mainstays as Fosters Crystals and Antiques, Henkeys Jewelers, Tom Crumplar's Malt Shop, Oakley's Barbershop, and so many more.

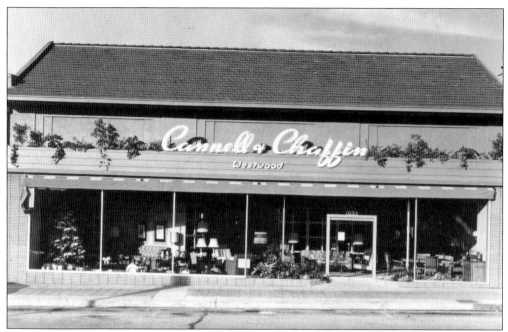

CANNELL & CHAFFIN, WESTWOOD, 1952. Designed by architect Roland Crawford in a modernistic show-window frontage design, the building located at 1035 Glendon Avenue between Weyburn and Kinross Avenues, was opened on December 10, 1951. Cannell & Chaffin was a fine furniture and interior design decorating store, originating on Wilshire Boulevard in Los Angeles. The site is now part of Palazzo Westwood Village Apartments.

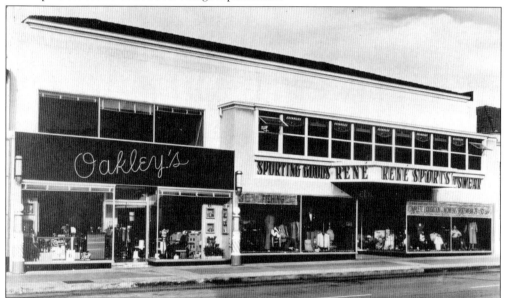

BROXTON AVENUE, 1952. Oakley's Barber Shop at 1051 Broxton Avenue was originally opened by brothers Bert and James Oakley and located on Vermont Avenue near the original UCLA campus. They moved to Westwood Village in 1929 and opened in the back of the Janss Dome building. They moved again to larger quarters at 1045 Broxton Avenue on August 7, 1947. Now located at 1061 Gayley Avenue, Oakley's is the last remaining original business in the Village.

La Ronda de las Estrellas Building, 1937. The opening of "Rotunda of the Stars" was in December 1933. Located on the corner of Lindbrook Drive and Glendon Avenue, La Ronda was built by Guy K. Harrison. At this time, the ground floor was occupied with shops owned by movie stars, such as Bebe Daniels and Mary Pickford.

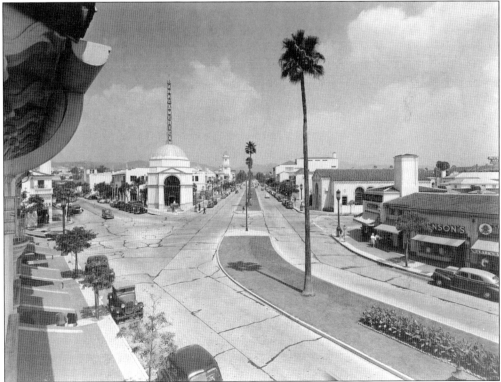

Westwood Village 1941. Looking north up Westwood Boulevard at the intersection of Kinross Avenue, this view shows the Janss Dome, center, occupied by the Bank of America in 1938. At right, on the southeast corner of Westwood Boulevard and Kinross Avenue, was the Owl Drug Store (later Owl Rexall), and on the northeast corner was the Citizens National Bank building.

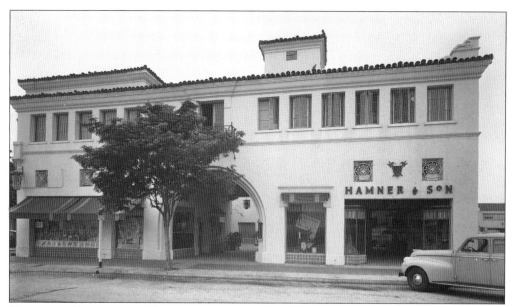

UNIVERSITY PROFESSIONAL BUILDING, 1943. Hamner & Son Clothiers is seen to the north of the Broxton Avenue entrance. John Morgan Hamner Sr. and John Morgan Hamner Jr. started the business in Westwood Village in 1929. Crawford Drugstore had been occupying the building since March 1930. Glazed ceramic Spanish tile is seen beneath the large showcase windows.

CRESCENT JEWELERS, 1946. Leonard and Sarah "Sunny" Friedman moved from Chicago soon after they were married and opened a tiny mom-and-pop shop in 1946 at 10911 Kinross Avenue in the University Professional Building. Selling fine jewelry, giftware, and tabletop silver, Crescent Jewelers relocated in 1963 to a larger store at 1055 Westwood Boulevard in the Janss Dome Building. In 1998, the store was renamed Sarah Leonard Fine Jewelers in honor of the two founders. After 64 years in Westwood, the store features three generations of Friedman and Abell family members and is the oldest existing merchant in the Village.

WESTWOOD HILLS PROMOTIONAL BOOKLET, 1940. This Westwood Hills booklet was published by the *Westwood Hills News-Press* and was distributed as a tribute to the Westwood Business Association and to the "village business men and women represented in this booklet and to Dr. Edwin and Harold Janss and A. H. Wilkins, the founders of a community which for all-around living—business and social, recreation, education, entertainment, is second to none in the country." It was in 1946 that Lenny and Sunny Friedman opened Crescent Jewelers on Westwood Boulevard, the oldest jeweler in Westwood Village. This booklet trumpeted Westwood Village as "America's most unique shopping center."

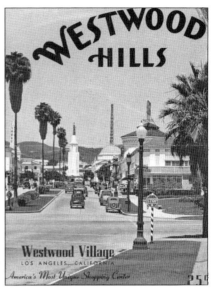

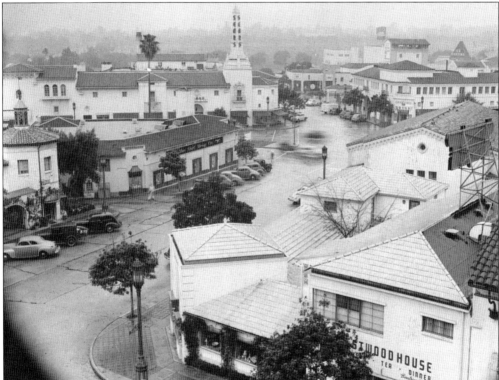

KINROSS AVENUE AT GLENDON AVENUE, 1944. This view looks west to Westwood Boulevard along Kinross Avenue with the Owl Drugstore and El Encanto Building at left. The Owl Drugstore, built in 1934, was designed by architect Allen E. Siple in the Mediterranean style. Across the street in the foreground is the Applegate Building, opened in 1938 on the northwest corner of Kinross and Glendon Avenues. It also was designed by Siple. In 1939, the Westwood House Restaurant opened inside the Applegate Building at 1097 Glendon Avenue by Beatrice Hudson and Gertrude Mostow. It now houses the Westwood Brewing Company.

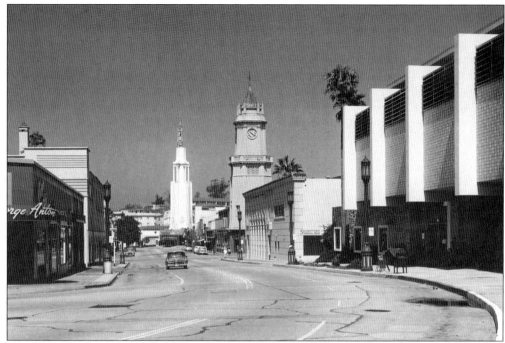

WEYBURN AVENUE, 1957. Looking west on Weyburn Avenue at Glendon Avenue, this vantage point shows George Anton Shoes at left. The shoe store was located in the former Master Service Garage that was opened in 1930 as the largest parking structure in the Village.

WESTWOOD HALL FOR WOMEN, 1954. The oldest apartment house in the Village opened in 1929 for student housing and was located on the southeast corner of Glendon and Weyburn Avenues. In 1943, one-third of all full-time students at UCLA were in uniform and special trainees of the U.S. Navy, and they occupied Westwood Hall. In 1949, the International Student Emergency Council took over parts of Westwood Hall for foreign students. Today the site is occupied by Trader Joe's Market.

EL PASEO BUILDING, 1955. Architects Norstrom and Anderson designed the El Paseo Building in the Spanish Colonial Revival style. Located at 1001–1009 Broxton and Weyburn Avenues, the building opened on January 7, 1932. In the late 1930s, Tom Crumplar's Malt Shop moved into the corner space. In 1960, Mario's Italian Restaurant opened in the space, followed by California Pizza Kitchen.

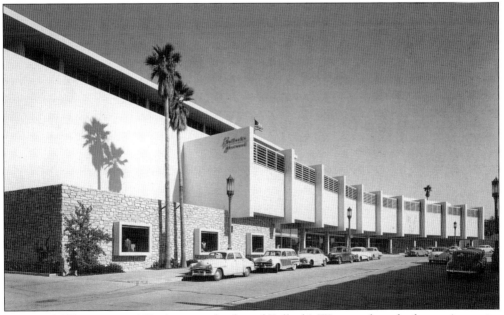

BULLOCK'S WESTWOOD, 1951. A new and enlarged Bullock's Westwood was built on a 4-acre site between Weyburn and Le Conte Avenues. Designed by architect Welton Becket, the store was three levels with an 850-car parking garage. It opened on September 5, 1951, and remained until 1996 when it was converted to a multitenant use for Housing Expo Design Center, Ralph's Fresh Fare, Best Buy, and Longs Drugs.

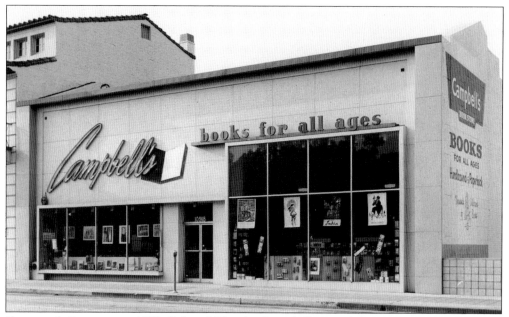

CAMPBELL'S BOOKSTORE, 1959. Bob and Blanche Campbell opened this store at 10918 Le Conte Avenue in 1929, moving the store from Vermont Avenue across from the original location of UCLA. Campbell's was the first retail business in the Village and served the UCLA student body for more than half a century. Campbell retired in 1974, but the store continued until 1984. Later it became Brentano's Bookstore, which also closed.

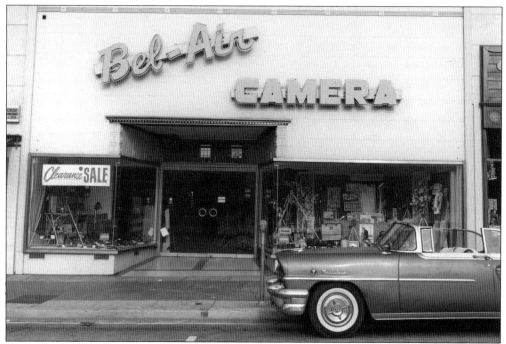

BEL-AIR CAMERA, 1957. Originally opened at 933 Westwood Boulevard on September 30, 1957, Bel-Air Camera moved to 927 Westwood Boulevard, then to 1025 Westwood Boulevard in 1979, and finally to 10925 Kinross Avenue at the northeast corner of Kinross and Gayley Avenues in 1999.

Nine
WESTWOOD VILLAGE
1960–2009

Following the departure of the Janss Investment Corp. from Westwood Village and the sale of its remaining properties in 1955, a major building campaign began in the Village. By 1960, the first high-rise was the Park Westwood Tower, a 14-story apartment house at Hilgard and Weyburn Avenues. In 1961, a major ownership change occurred when Harvey L. Silbert, Bernard M. Silbert, and M. A. Borenstein bought half the Westwood Village business section from S. Jon Kreedman, who had an option on the property from Arnold S. Kirkeby. The Silberts-Borenstein purchase included property containing 50 retail stores and 12 parking lots. In early 1963, a 21-story office building named the Wilshire-Westwood Building opened at 1100 Glendon Avenue.

The 37th anniversary of Westwood Village was celebrated with the "Turning on of the New Street Lights" celebration on June 13, 1966. By 1971, Westwood Village was a nightlife destination where visitors could stroll in a safe environment. Ships Coffee Shop was a popular hangout. In 1973, lines formed around the block at the Mann National Theatre to see *The Exorcist*. Three movie theaters in Westwood Village included the Village, Bruin, and Crest. Between 1966 and 1975, the number of movie screens grew from 3 to 17. The movie theater era brought shoppers and a new boom to the Village. In 1973, Donald and Kirsten Combs purchased the old Masonic Temple building on Le Conte Avenue, opened Contempo, remodeled the theater, launched a small restaurant and art gallery, and in effect created a Westwood Cultural Center.

In 1978, Glendale Federal Savings replaced the Bank of America in the Janss Dome building. By 1982, the last of the fine Village grocery stores closed, and the Sears, J. C. Penney, Woolworth, and J. J. Newberry stores were gone. In June 1988, eight Westwood buildings were declared Los Angeles City Historic-Cultural Monuments. The 60th anniversary of Westwood was celebrated in 1989 with an October 20th proclamation by the mayor as Janss Day. In January 1993, UCLA purchased the 498-seat, 1929-era Masonic Affiliate Clubhouse from owner Kristen Combs, which then housed the Contempo Westwood Center and Westwood Playhouse. In April 1996, music mogul David Geffen donated $5 million to the playhouse, which was then renamed the Geffen Playhouse. At the beginning of April 2008, the Palazzo Westwood Village prospect on Glendon Avenue was underway, providing 350 luxury apartment units and 50,000 square feet of ground-floor retail space. September 2009 marked the 80th anniversary of the opening of Westwood Village.

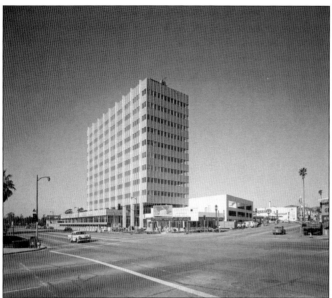

LINDE MEDICAL PLAZA, 1961. This October 1961 photograph shows the ending phase of construction of the Linde Medical Plaza. Located at 10901–10937 Wilshire Boulevard, Linde Medical Building was built by Morris Linde of Linde Enterprises on land owned by Janss executive George Gregson, and Paul R. Williams was the architect. The 12-story medical office building was constructed of steel and concrete with marble entrances and was originally medicine-green in color.

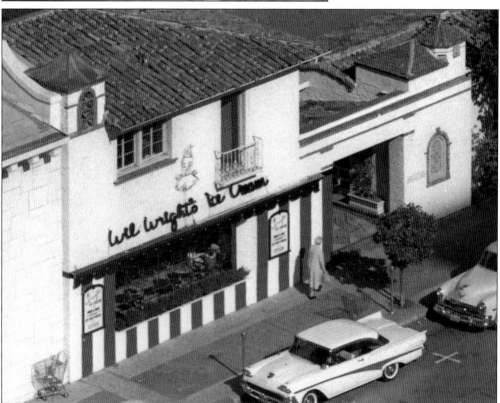

WIL WRIGHT'S, 1962. Located in the La Ronda Building at 10879 Lindbrook Avenue, the Wil Wright's in Westwood Village seen here was one outlet of Wil Wright's Ice Cream Parlors in the Los Angeles area. It was a popular destination for more than 30 years, drawing local residents and celebrities alike. *Twilight Zone* writer Rod Serling used the Westwood Wil Wright's for informal production meetings.

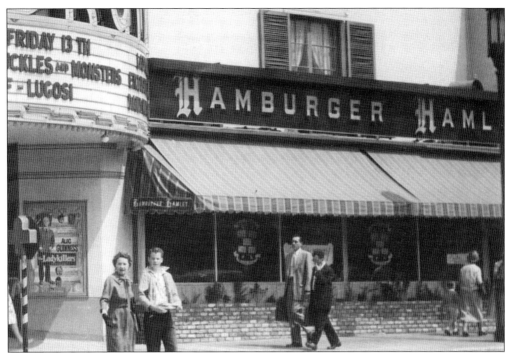

HAMBURGER HAMLET, 1960. Harry and Marilyn Lewis opened their original Hamburger Hamlet restaurant on the Sunset Strip in 1950, and it became a hangout for celebrities. This second location was on the site of the old Brits Coffee Shop on Weyburn Avenue in 1952. "We Love Westwood!" was the Hamlet's slogan in the Village. In December 1985, Hamlet Gardens opened in the La Ronda Building.

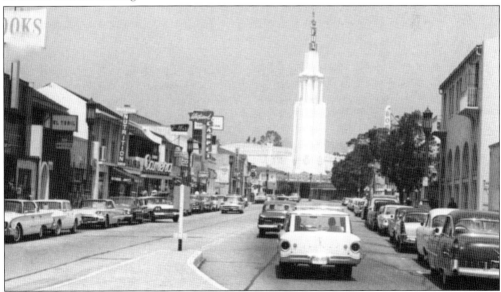

BROXTON AVENUE, 1963. This view of Broxton Avenue looks north to the Fox Westwood Village Theatre. On the west side of Broxton Avenue, from left to right, were Westwood Books, El Toril Mexican Restaurant, Westwood Nutrition Center, Campus Camera, Westwood Carpets, and Stewart Photo Company.

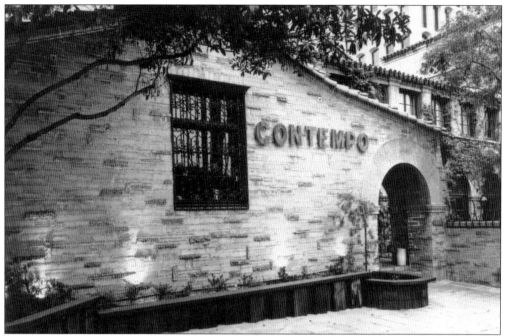

CONTEMPO WESTWOOD CENTER, 1979. In 1971, Contempo furniture and arts store relocated to the first floor of the former Masonic Affiliate Clubhouse at 10866 Le Conte Avenue. In 1974, Contempo owners Donald and Kirsten Combs allowed the theater to be remodeled by producers Leonard Blair and Margy Newman into a 486-seat legitimate theater with a balcony. The renamed Westwood Playhouse opened on March 26, 1975. Stratton's Restaurant opened in the Contempo Building in 1976 and became a popular dining destination.

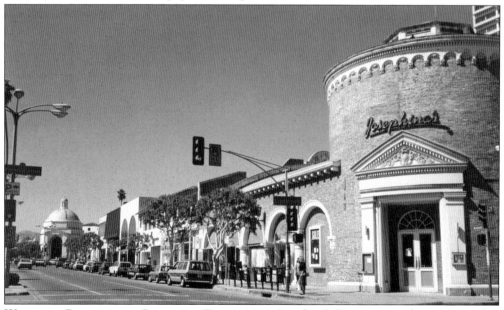

WESTWOOD BOULEVARD AT LINDBROOK DRIVE, 1989. Josephina's Restaurant, right, was located in the 1929 Ralph's Grocery Company building. Prior to Josephina's, it was home to the Bratskellar. Today it is the site of Peet's Coffee.

HAMMER MUSEUM, 1989. On January 21, 1988, Armand Hammer, CEO of Occidental Petroleum Corp., announced he would build an art museum in Westwood Village. Designed by noted architect Edward Larrabee Barnes, the Hammer Museum opened in November 1990 at 10899 Wilshire Boulevard at the base of the Occidental Petroluem tower. The Hammer Museum opened the 295-seat Billy Wilder Theater, designed by architect Michael Maltzan in cooperation with the UCLA Film and Television Archive.

EL ENCANTO BUILDING, 2009. Since the El Encanto Building opened in 1931, many businesses, including Fosters Crystal and Antiques, a school of dance, El Encanto Tea Shop, Westwood Theatre Guild, and offices, occupied this landmark, which was designed by Howard Wells in the Andalusian style. Acapulco Mexican Cantina Restaurant has been at 1109 Glendon Avenue since 1985.

JERRY'S FAMOUS DELI, 2009. Located at 10925 Weyburn Avenue, this Jerry's Famous Deli in Westwood Village opened in June 1996. The building had housed Westwood Florist and Brooks Photography in the 1950s. Jerry's Deli expanded into the neighboring building, combining two buildings into one restaurant.

WILSHIRE BOULEVARD AT GAYLEY AVENUE, 2009. At left is the Westwood Medical Plaza (formerly Linde Medical Plaza) at 10921 Wilshire Boulevard. At far right is Helmut Jahn's boldly designed office building, "The Tower" on the southeast corner at 10940 Wilshire Boulevard. Farther east on Wilshire Boulevard, at left, is the Oxy Building (Occidental Petroleum) at 10889 Wilshire Boulevard.

Ten

MOTION PICTURES AND TELEVISION

In 1923, Janss Investment Company representatives invited independent film companies to purchase land and build in Westwood. Four Hollywood outfits purchased plots, including Fox Film Corporation, Harold Lloyd Corporation, National Film Corporation, and Christie Film Company. In May of that year, William Fox Studio announced a move to a new 450-acre plot purchased from the Janss Company, bordered by Santa Monica Boulevard to the north, Fox Hills Drive to the west, future site of the Westwood Public Golf Course to the east, and Pico Boulevard to the south.

Exhibitors Herald announced that the new Fox Studio, which opened in 1928, cost $2 million. By the late 1950s, Harold Lloyd's movie ranch was replaced by the Mormon temple, and the National and Christie plots became residential developments.

With the opening of the Westwood Village business district between 1929 and 1931, Fox Film Corporation negotiated the construction of a movie palace to be named the Fox Westwood Village Theatre, owned by Fox Theatres executive Spyros P. Skouras. It opened on August 14, 1931. Los Angeles's first drive-in movie theater opened in September 1934, on the south side of Pico Boulevard at the end of Westwood Boulevard, south of the Janss Westwood Development. In 1937, the Bruin Theatre was built by Fox West Coast Theatres, the companion to the Fox Westwood Village Theatre across the street. In 1940, the UCLAN (Crest) Theatre opened on Westwood Boulevard. The UCLAN was opened as a live theater, but World War II brought the need for a newsreel house, and after the war it was converted to a film theater. Throughout the 1950s and 1960s, there were premieres and special event screenings at the three Village theaters, bringing publicity and visitors to Westwood Village.

In 1965, three theaters operated in the Westwood Village area, but by 1970 there were 10 screens, and by 2007 multiplex construction or remodeling made it 17. Major premieres in the Village included *Batman* on June 19, 1989; *Interview With the Vampire* at the Fox Westwood Village and Bruin Theatres on November 9, 1994; *Star Wars: Episode I, The Phantom Menace* on May 19, 1999, at the Fox Westwood Village Theatre; and the remake of *Ocean's Eleven* in 2001 at the Fox Westwood Village Theatre.

A very short list of films shot in Westwood Village includes *Janie* (1944), *The Accused* (1948) with Loretta Young, *Bunco Squad* (1950), *Ransom* (1955) with Glenn Ford, *Man Afraid* (1956), *The Young Stranger* (1957), *Girls on the Beach* (1965), and *Gotcha!* (1985).

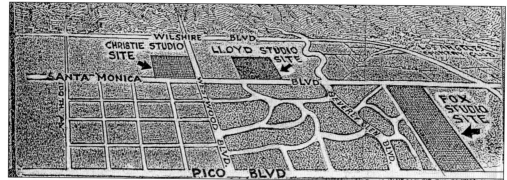

PROPOSED FILM STUDIO SITES IN WESTWOOD, 1923. In May 1923, it was announced that the Christie Film Company would build a new studio on 230 acres north of Santa Monica Boulevard, bordered by Westwood Boulevard and Massachusetts and Kelton Avenues. At the beginning of 1924, the National Film Corporation announced it purchased a studio site located on Westwood Boulevard adjoining the Christie studio site north of Santa Monica Boulevard. The National Film Corporation and Christie Film Company never realized its dream of a new studio in Westwood.

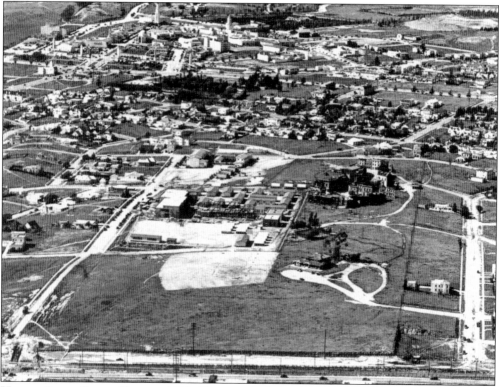

HAROLD LLOYD STUDIO RANCH, 1928. This view looks north from Santa Monica Boulevard along the bottom, with Selby Avenue at left, Manning Avenue at the right, and Westwood Village at top left. Film star Harold Lloyd purchased a large property in 1923 where John Wolfskill had built a home in 1913 on the north side of Santa Monica Boulevard, near Selby Avenue. In 1928, Lloyd built a New York street setting on the site for his film *Speedy*. Other studios used the set, but the Great Depression shelved his plans for a regular working studio. In 1934, Lloyd sold 10 acres of the northern property to the Los Angeles Board of Education, which were developed into Ralph Waldo Emerson Junior High School in 1937.

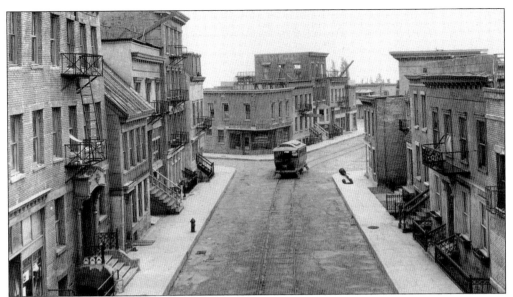

HAROLD LLOYD'S STUDIO RANCH, 1928. Lloyd planned a motion picture studio in Westwood in 1924 and used the site as a location ranch. His established studio on Santa Monica Boulevard in Hollywood did not have much of a backlot. This New York Street set was built for the 1928 film *Speedy* and was a re-creation of a Brooklyn neighborhood with a horse-drawn trolley car. Lloyd went to New York to film many of the scenes for the film but used his Westwood set for key scenes. In 1936, the Selznick Film Company used the set for *Little Lord Fauntleroy*, starring Freddie Bartholomew.

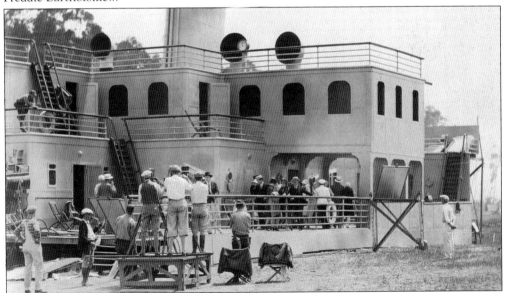

CHRISTIE FILM COMPANY STUDIO RANCH, 1926. Film pioneer and studio mogul Al Christie purchased land from the Janss Investment Corporation in 1923 on the northwest corner of Santa Monica and Westwood Boulevards. Christie used the site as a location ranch, and in 1926, the company shot scenes for *Ocean Blues* there on an ocean liner set. Al and Charles Christie invested money in the new "Studio City" development on Ventura Boulevard in the San Fernando Valley and gave up on their Westwood property.

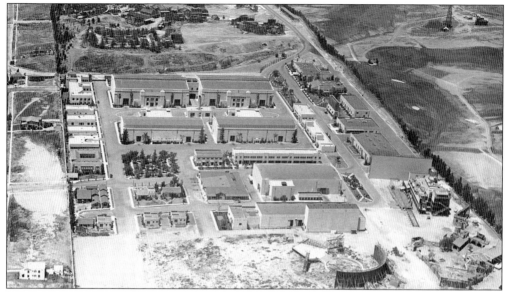

FOX MOVIETONE STUDIO–FOX HILLS UNIT, 1929. The *Hollywood Filmograph* announced on August 28, 1926, "Fox-Westwood Opening Sunday . . . Public is invited to view the greatest outdoor studio . . . Fox Hills, the great 150-acre 'location studio' of the Fox Film Corporation will be opened formally to the public on Sunday August 29th. With the blare of bands, orchestra, cowboys, Indians, United States Marines and motion picture stars, all will follow the raising of the first flag to the pinnacle of the great staff that surmounts the main Spanish entrance of the new $2,000,000 film plant on Santa Monica Boulevard. Tom Mix will head one of the events assisted by his troupe of cowboys." There was a tour of the location ranch sets that were used in such films as *What Price Glory, The Country Beyond,* and *Whispering Wires,* among many others.

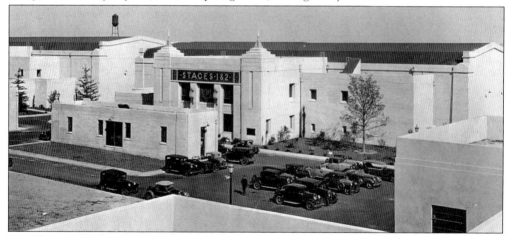

FOX MOVIETONE STUDIO, 1930. Sound motion pictures were introduced in 1926, and the Fox Company was already involved with sound technology. The company built a sound film studio on the Westwood site. The first sound stages were dedicated as Fox Movietone Studios on October 28, 1928, on the southern portion of the Fox Hills Tract fronting Pico Boulevard. A Fox Studio expansion plan relocated the main studio lot to Westwood from East Hollywood. By 1930, the 54 acres between Santa Monica and Olympic Boulevards were devoted to exterior settings. Two bridges connected the southern 54 acres of the property across Country Club Road (Olympic Boulevard) to the production facilities, including future sound stages.

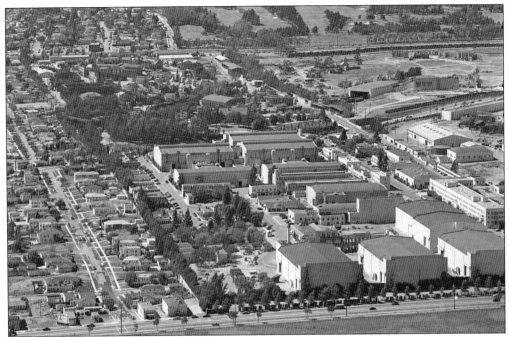

20TH CENTURY-FOX STUDIOS, 1948. This view looks northeast from Pico Boulevard and Fox Hills Drive at left to Santa Monica Boulevard at the top of the photograph. Over the next 15 years, the studio property expanded east to the Beverly Hills border. A "Western Town" was built as well as production facilities and lakes and sky backings. Films made on the site of the former Westwood Public Golf Course included *Fury At Furnace Creek* starring Victor Mature, *The Luck of the Irish* starring Tyrone Power, and *When My Baby Smiles At Me* with Betty Grable.

20TH CENTURY-FOX STUDIOS, 1965. A northwest vantage takes in the studio property building and the main entrance off Pico Boulevard. In 1935, the Fox Film Corporation and 20th Century Productions, headed by Joseph Schenck and Darryl F. Zanuck, merged creating 20th Century-Fox. Some of the films made on the lot included *The Sound of Music* starring Julie Andrews, *Flight of the Phoenix* starring James Stewart, and *Wild on the Beach* with Sonny and Cher.

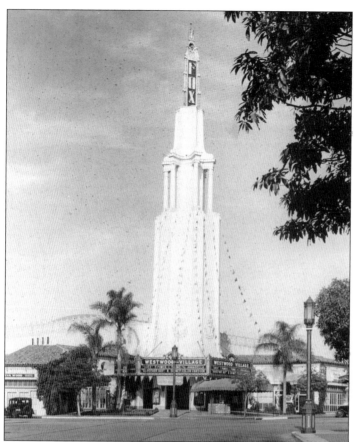

FOX WESTWOOD VILLAGE THEATRE, 1938. The opening of the towering Fox Westwood Village Theatre was celebrated here on August 14, 1931. Westwood Boulevard was decorated with blue and gold UCLA colors, and thousands turned out. The newest addition to the Fox West Coast Theatre chain was designed by Percy Parke Lewis, Janss architect, and featured a towering white spine with the name Fox in neon at the top. The first film to open at the Fox Westwood Theatre was *A Free Soul*, starring Norma Shearer, a young Clark Gable, and Lionel Barrymore.

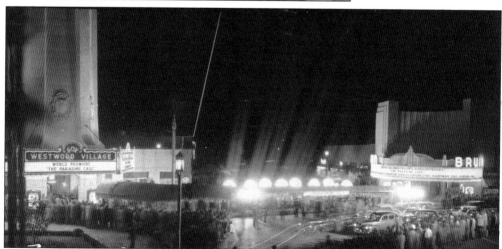

FOX VILLAGE AND BRUIN THEATRES, 1948. The first dual premiere held at both theaters simultaneously was Alfred Hitchcock's *The Paradine Case*. The stars and their guests were seated in the Fox Westwood Village Theatre, and the overflow crowd was directed to the Bruin Theatre. The film was started at the Fox Westwood Village Theatre, and after the first reel was completed, it was taken over to the Bruin Theatre where it was shown about 15 minutes later. This tradition of the dual premiere continues to this day.

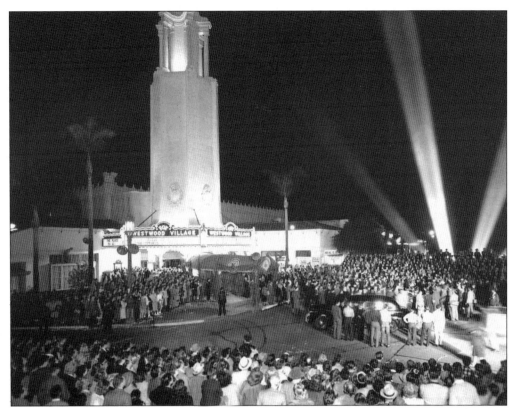

Fox Westwood Village Theatre, 1948. The second dual premiere, this time for the film *The Adventures of Casanova*, was held just one month later in Westwood Village, continuing the tradition of using both the Village and Bruin Theatres for one premiere. This was a Los Angeles press photographers pre-premiere that attracted thousands. The tradition of premiering films in these two landmark Westwood theatres became a favorite studio practice.

Bruin Theatre, 1948. The Bruin Theatre opened in 1937. Designed by architect S. Charles Lee in Streamline Moderne styling, the 900-seat theater was decorated in a blue and gold color scheme to conform to the general Westwood Village utilization of the UCLA colors.

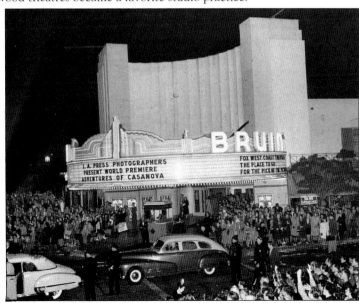

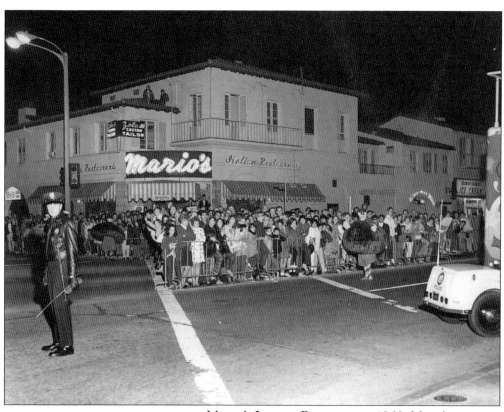

MARIO'S ITALIAN RESTAURANT, 1968. Mario's restaurant at 1001 Broxton Avenue opened in the El Paseo building. The owner, Mario Angelini, took over the former Tom Crumplar's Grill and Malt Shop in February 1964. Here, in 1968, the premiere of *Yellow Submarine* included entertainment for the fans by the Blue Meanies, characters from the film, on Weyburn Avenue. After 35 years in Westwood Village, Mario's Italian Restaurant closed in September 1998. Cary Grant, Natalie Wood, and members of the UCLA football team were among those seen eating at Mario's. California Pizza Kitchen took over the location in 1998.

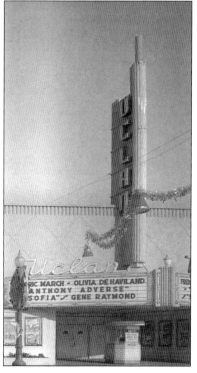

UCLAN/CREST THEATRE, 1948. Opened as a live theater in 1940, the UCLAN was converted to a newsreel house during World War II and later played foreign and independent films between 1946 and 1956. By July 1956, it was the Crest Theatre. In the 1970s, the Crest Theatre was renamed the Metro, and in 1985 Pacific Theatres renamed it the Pacific Crest. Remodeled in 1987 in Hollywood Art Deco style with murals decorating the auditorium walls, the Pacific Crest was listed as Los Angeles City Historic-Cultural Monument No. 919 in May 2008 and was renamed the Majestic Crest.

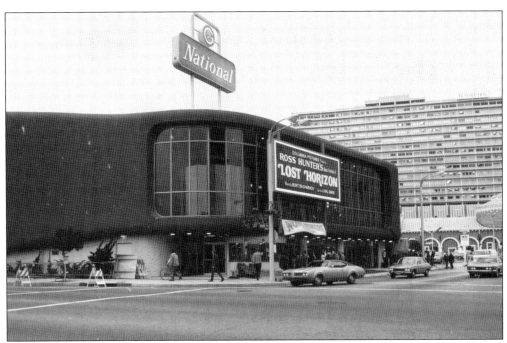

NATIONAL THEATRE, 1973. National General Theatre Corporation broke ground on June 16, 1969, for the new National Theatre at the northeast corner of Gayley Avenue and Lindbrook Drive. Newspapers announced, "Shirley Jones will officiate at the ceremonies." Built by theater magnate Ted Mann, the newly constructed 1,112-seat National Theatre opened on March 26, 1970, with the premiere of *The Boys in the Band*. It was the last single-screen theater built in Los Angeles County and was demolished in January of 2008.

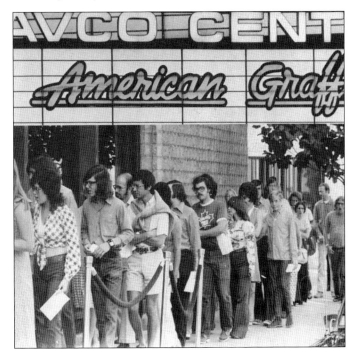

AVCO CENTER CINEMA, 1973. Operated by General Cinema Corporation, the AVCO Center Cinemas at 10840 Wilshire Boulevard started out as a triplex on May 24, 1972. The main theater at the AVCO was the first THX-certified theater in Los Angeles for the opening of *The Return of the Jedi*. The AVCO Cinema opened all three of the original *Star Wars* features. In 1993, the main downstairs auditorium was closed and divided into two theaters. The complex reopened as a fourplex. AMC Theatres took over the AVCO, and the name was changed again to AMC AVCO Center 4 in 1999.

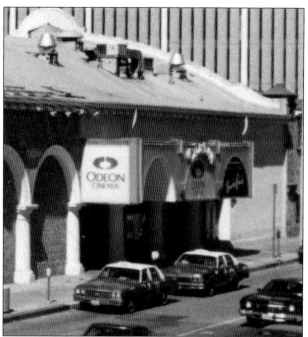

ODEON CINEMA, 1989. Originally opened as the UA Theatre at 10887 Lindbrook (located in a portion of the former Ralph's Market), the Odeon Cinema opened on April 11, 1969, with the world premiere of *A Boy . . . a Girl*. The UA Westwood was later known as UA, UA Egyptian, Odeon Cinema, and Mann Festival. On August 1, 2009, the *Los Angeles Times* announced the reduction of movie theaters in Westwood Village with the headline "Fading to black in Westwood." The 2008 demolition of the Mann National Theatre and the previous losses of the Mann Westwood 4 and Mann Plaza led to a major reduction of theaters in the Village. The closing of the Mann Festival Theatre was in 2009.

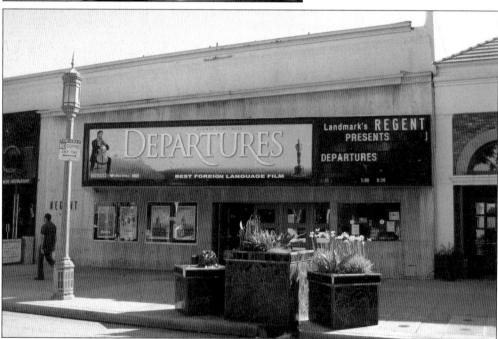

LANDMARK'S REGENT THEATRE, 2009. Opened in September 1966 as the Laemmle Regent Theatre, this theater is now operated by Landmark Theatres. In April 1987, Westwood was the mecca of movie theaters in Los Angeles, including the following: the AVCO General at 10840 Wilshire Boulevard, Mann Regent at 1045 Broxton Avenue, Mann Plaza at 1067 Glendon Avenue, Mann National at 10925 Lindbrook Drive, Mann Westwood at 1050 Gayley Avenue, Mann Bruin at 948 Broxton Avenue, Mann Village at 961 Broxton Avenue, UA Coronet on Westwood Boulevard, UA Egyptian at 1087 Lindbrook Drive, and the Pacific Crest Metro at 1262 Westwood Boulevard.

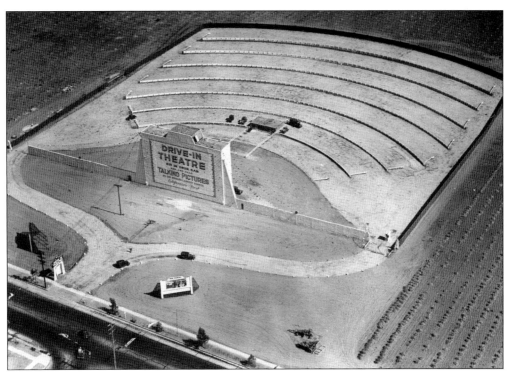

DRIVE-IN THEATRE, 1934. Located at the end of Westwood Boulevard on the south side of Pico Boulevard, this drive-in theater was the first of its kind in Los Angeles. Opened on September 9, 1934, the theater could accommodate 500 automobiles. A 1934 advertisement announced, "Visit California's Unique Drive-In Theatre." Although technically not within the Janss Westwood Hills development, the theater was commonly known as the "Westwood Drive-In Theatre." In the wake of neighbors' complaints, it was relocated to the northeast corner of Olympic Boulevard and Bundy Drive.

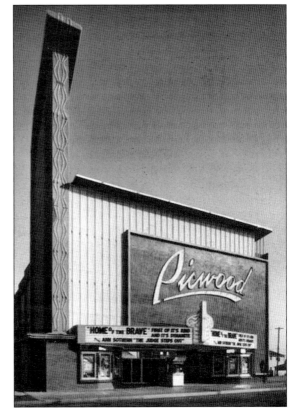

PICWOOD THEATRE, 1949. Located at 10872 West Pico Boulevard on the original site of the Drive-In Theatre, which closed in 1944, the Picwood Theatre opened in 1948 as a 900-seat cinema offering first-run films. In September 1985, the Picwood closed to make way for the Westside Pavilion expansion.

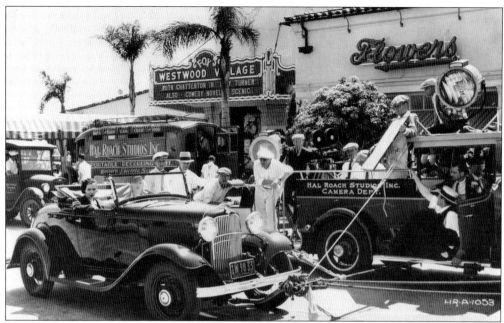

FILMING IN WESTWOOD VILLAGE, 1933. The Hal Roach Studio production of *Beauty and the Bus* was partially shot in Westwood Village. Hal Roach Studio stars Patsy Kelly and Thelma Todd are seen in a car on Broxton Avenue in front of the Fox Westwood Village Theatre. Director Gus Meins (center in white) shoots automobile stunt scenes.

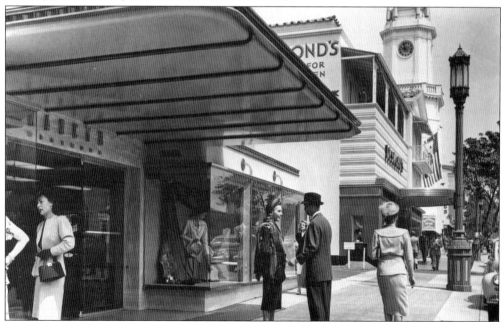

ON LOCATION IN WESTWOOD VILLAGE, 1948. Columbia Pictures shot scenes in Westwood Village for *I Love Trouble* starring Franchot Tone, Janet Blair, and Lynn Merrick. Seen here in front of Nancy's at 1025 Westwood Boulevard, Tone plays a private detective investigating the past of a rich man's wife, played by Merrick. This film was remade into Richard L. Bare's *Girl on the Run* (1958), the forerunner of television's *77 Sunset Strip*.

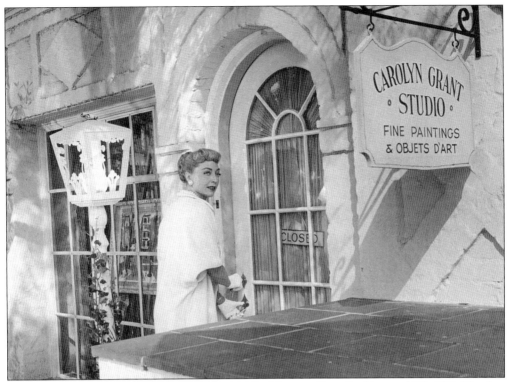

FILM LOCATION IN WESTWOOD VILLAGE, 1955. The Harrison Patio Building at 1129–1131 Glendon Avenue was used as a film location for Republic's *No Man's Woman*, starring Marie Windsor. Directed by Franklin Adreon, the film is a crime-mystery story with Windsor's character an art gallery owner in Westwood Village. The gallery location was originally the Westwood Children's Boutique at 1129 Glendon Avenue.

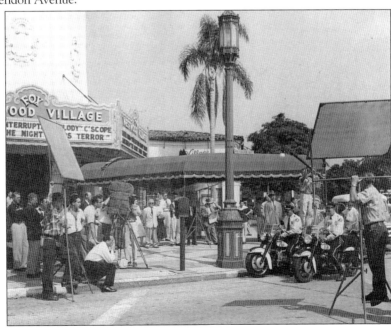

WESTWOOD VILLAGE FILM LOCATION, 1956. A scene from MGM's *Ransom* is seen here filming in front of the Fox Westwood Village Theatre. Directed by Alex Segal and starring Glenn Ford, this family drama used Westwood Village as a location filming site.

www.arcadiapublishing.com

Discover books about the town where you grew up, the cities where your friends and families live, the town where your parents met, or even that retirement spot you've been dreaming about. Our Web site provides history lovers with exclusive deals, advanced notification about new titles, e-mail alerts of author events, and much more.

Arcadia Publishing, the leading local history publisher in the United States, is committed to making history accessible and meaningful through publishing books that celebrate and preserve the heritage of America's people and places. Consistent with our mission to preserve history on a local level, this book was printed in South Carolina on American-made paper and manufactured entirely in the United States.

This book carries the accredited Forest Stewardship Council (FSC) label and is printed on 100 percent FSC-certified paper. Products carrying the FSC label are independently certified to assure consumers that they come from forests that are managed to meet the social, economic, and ecological needs of present and future generations.

Cert no. SW-COC-001530
www.fsc.org
© 1996 Forest Stewardship Council